YO-CAR-527

DONNA BLAKE BIRCHELL

NEW MEXICO WINE

An Enchanting History

FOREWORD BY GORDON STEEL

AMERICAN PALATE

Published by American Palate
A Division of The History Press
Charleston, SC 29403
www.historypress.net

Copyright © 2013 by Donna Blake Birchell
All rights reserved

Front cover, top: Heart of the Desert Winery vineyards. *Courtesy of the author.* *Bottom*: The welcoming Ponderosa Valley Vineyard & Winery. *Courtesy of the author.*
Back cover, left: Heart of the Desert vineyards in the beautiful Tularosa Basin. *Courtesy of the author.* *Center*: Shiraz grape clusters at Fort Selden Winery. *Courtesy of the author.* *Right*: Casa Rondeña Winery is a touch of Tuscany in Albuquerque, New Mexico. *Courtesy of the author.* *Bottom*: Thriving grapevines in the vineyards of New Mexico. *Courtesy of the author*

First published 2013

Manufactured in the United States

ISBN 978.1.60949.643.2

Library of Congress CIP data applied for.

Notice: The information in this book is true and complete to the best of our knowledge. It is offered without guarantee on the part of the author or The History Press. The author and The History Press disclaim all liability in connection with the use of this book.

All rights reserved. No part of this book may be reproduced or transmitted in any form whatsoever without prior written permission from the publisher except in the case of brief quotations embodied in critical articles and reviews.

Dedicated with great gratitude to all those past and present who have toiled long hours in the vineyards and wineries of New Mexico, against all elements, to coax a delightfully delicious nectar from the humble grape.

Contents

Foreword

I've spent a good part of my adult life away from New Mexico and always had the internal desire to return home to the Land of Enchantment. I envisioned establishing a vineyard here as my family had done in the later part of the 1800s, along with a winery in the little town of Mesilla, New Mexico.

While away, I missed our "laid-back lifestyle," "culture steeped with history" and "beautiful sunsets." I welcome each and every one of you to come and enjoy not only my wines but also those from vineyards all over the state. More than that, come energize yourself with a way of life that feeds the soul!

For those of you who might be a little skeptical of our industry, I have added a few facts from the *2007 Economic Impact of New Mexico Wineries on the State's Economy*. Twenty-seven wineries in New Mexico were selling wine made from grapes during 2007. Wine sales by those wineries totaled $19,986,000, and the additional sales of non-wine items in the tasting rooms were estimated at another $999,595.

Revenues from five festival gate receipts, sales of non-wine revenues and parking receipts were estimated at $780,000. Direct revenues spent in the state associated with the wine industry totaled $21,765,595. In addition to these direct revenues, an estimated $6,614,496 of indirect spending and $3,631,773 of induced spending resulted in an estimated total impact of over $32,000,000 on the economy in the state

A total of 198,000 cases of wine, nearly 40 percent, were sold to out-of-state residents either by out-of-state shipments through national wholesale distributors, Internet sales or wine club shipments or by out-of-state tourists' purchases in

the tasting room. Sales to consumers from outside the state have a greater total impact on the state's economy than sales made to in-state consumers.

The New Mexico wine industry has experienced significant growth in recent years since that study was completed. We have obtained dozens of medals, including gold, silver, bronze, double gold, Best of Show and Best in Class from both the New Mexico State Fair and the Finger Lakes International competitions.

These have been achieved in a very short time. Robert Parker, national wine writer from *Wine Spectator*, is quoted as saying, "Wow, not what I expected from a place known for their tamales!"

As of 2012, there are fifty-four licensed wineries and another six that I know of in the planning stages, as well as over ten wine festivals statewide. That is over 100 percent growth in five years and still growing!

Use *New Mexico Wine: An Enchanting History* as a guide to enrich your life by tasting a wide variety of wines made by winemakers who take an artistic approach to their profession. Each winery (as this book illustrates) is as unique as New Mexico itself—where history, community, culture and its people create a life that is reminiscent of the past yet modern in its conveniences.

Please do not forget the great food that pairs so well with those wines. These tantalizing meals, made with care, also bring out our cultural diversity and should not be missed. During your stay, find one of our treasured out-of-the-way hotels, bed-and-breakfasts or even a postwar-era motel where that rich culture can be appreciated along with some of the great wine you will find along your New Mexico wine trail adventure.

As a thirty-four-year U.S. Air Force veteran who takes an active role in promoting New Mexico wines, I have been making wine for over forty years and studied viticulture at the University of California–Davis and Washington State University. I have served in the past as secretary for both the New Mexico Vine and Wine Society and the New Mexico Wine Growers Association; I have also been an active member of New Mexico Wine Country and was president of the New Mexico Wine Growers Association during 2011 and 2012.

I am proud to promote the New Mexico wine trail and passport program offered by the New Mexico Wine Growers Association, publisher of *Enchanted Vines* magazine, which promotes New Mexico wines and the developing New Mexico wine industry roadside trail program.

Gordon Steel
Owner/Winemaker
Rio Grande Vineyards and Winery

Acknowledgements

I t has always been my wish that the words "thank you" were somehow more regal, more descriptive so as to better impart my true feelings of appreciation to all the people who were instrumental in bringing this project to life. This book would not have been possible without the knowledge, hard work and dedication of the following people who gave up precious time from their lives to educate a novice:

Henry and Mary Street, vintners/owners of Ponderosa Vineyards—an extra special thank you for keeping the history of New Mexico wine alive with your wonderful work, *The History of New Mexico Wine*. You have certainly done the hard work, opening the door for others to follow. Many thanks for your generous hospitality and accepting my plea to take time out of your life to proofread this manuscript.

Gordon Steel, Rio Grande Vineyards & Winery, great gratitude for all you do for the New Mexico wine industry, and thank you for providing an extremely informative foreword.

The following people have played major roles in the formation of this volume, and it is with a humble heart that I convey my sincere gratitude:

Keith Johnston, Corrales Winery
Dave Wickham, Tularosa Vineyards and Winery
John Calvin, Casa Rondeña Winery
Ron Dolin, Don Quixote Distillery
Richard and Eileen Reinders, Estrella del Norte Vineyard

ACKNOWLEDGEMENTS

Dale Balzano, Balzano/Spirits of Seven Rivers Winery
Dale and Penny Taylor, Cottonwood Winery
Bridget Perrault, Director, New Mexico Wine Growers Association
Dana Koller, New Mexico Wine Country
Murt Sullivan, park guide and dear friend, Salinas Pueblo Missions
Charles B. Stanford, processing archivist, Rio Grande Collection, New Mexico State University
Sibel Melik, senior archivist, New Mexico State University Library
Elizabeth Flores, New Mexico State University Library

For the crew at Chenega Security at the Federal Law Enforcement Training Center in Artesia, New Mexico, who were genuinely interested in the book's progress and urged me forward to completion—thank you for welcoming me into the fold and for your unwavering support.

Samantha Villa, friend extraordinaire, who began this dream by forwarding one phone call: *muchas gracias a usted mi querido amigo!*

To all the many dear friends who eagerly volunteered for wine tasting research and were over-the-top enthusiastic about this project—your input, support and friendship, as always, is completely invaluable.

For my editor, Aubrie Koenig, who listened patiently to my enthusiastic-yet-sometimes-unreasonable ideas, had a belief in this project from the beginning and went to bat for it so the book could become a reality—so grateful for you. You're the best! Also, to Julia Turner and the rest of the wonderful editors and staff of The History Press, thank you for allowing me to complete this journey.

Most especially, I can't thank my family enough for their support and encouragement, for listening to my endless ramblings about wine and history without showing much of a glazed look on their faces, for being polite as I interrupted television shows and for purchasing even more wine for the already bulging collection. Jerry, Michael and Justin Birchell, you're wonderful!

To you all, I raise my glass high with deepest gratitude! Salud! Sláinte!

Determination, Struggles and Triumph

It is said the Romans traded wine for slaves while the Ancient Egyptians believed wine storage to be a form of alchemy. Hippocrates used wine in nearly every one of his remedies with some success. A Roman woman was not allowed the luxury of drinking wine. If her husband should find her partaking in the libation, it was his right to kill her. Wine was also used as currency during medieval times because it maintained its value.

Quick, think of the oldest wine-producing state in the United States. Was your answer California? Or maybe even an eastern seaboard state? The answer may surprise you. Nine years after the Pilgrims set foot on Plymouth Rock, New Mexico was already in winemaking mode.

New Mexico is proud to have the longest history of wine production in the United States, officially beginning in 1629 with the planting of the first grapevines by Franciscan friars. Originally born out of necessity, the New Mexico wine industry, like that of California, has religious roots in missionary settlements. The road to this point was long and filled with many obstacles. To say it was turbulent would be an understatement, but it is thanks to these bumps, both minor and major, that we enjoy the abundance of wines available to us today.

The Spanish

Like many explorers before him, Don Juan de Oñate came to New Mexico Territory in search of rumored riches and treasures, such as Cibola and the Seven Cities of Gold. In 1595, Don Cristobal, Don Juan de Oñate's father, commissioned his son to lead a small group of Spanish colonists, soldiers and cattle along the Rio del Norte (now the Rio Grande), the river that bisected the then territory of New Mexico, to establish settlements.

His expedition, which began on January 26, 1598, was said to be the first successful exploration of its kind. Instead of gold, the treasure found on this journey was mainly rich, volcanic soil along the riverbanks, perfect for growing crops and raising livestock. Also in the group were Spanish monks whose main mission was to convert those they viewed as the heathens of this new, savage land to Christianity.

Believing their way of life to be the only correct one, Oñate and his party claimed the land and forced the inhabitants, sometimes brutally, to pledge allegiance to King Phillip of Spain and a god new to the native people. Through his own words, Oñate wrote his reasons for the exploration.

> *Another reason* [for the conquest of New Mexico] *is the need for correcting and punishing the sins against nature and against humanity which exist among these bestial nations and which it behooves my King and Prince as a most powerful lord to correct and repress…another reason is the great number of children born among these infidel people who neither recognize nor obey their true God and Father.*

It was with these words that Oñate claimed sovereign rights to the territory and "of its kingdoms contiguous thereto."

In 1608, without the discovery of significant amounts of gold and other precious metals, the future of the New Mexico Territory itself was in jeopardy. The colony was simply costing more to maintain than what it was worth to the Spanish crown. Friar Lázaro Ximénez, personally sent by Oñate, traveled to Mexico as an ambassador for the entire region to plead with the viceroy not to abandon New Mexico as a lost cause. Although New Mexico was an expensive project, the church had converted seven thousand natives to Christianity.

The area had been a disappointment. It was a land of poverty, and the conversion of the native peoples was proving too slow-going to satisfy the Spanish crown. Nevertheless, the friar returned to New Mexico upon the

advice of the viceroy to complete the mission: to save souls. He later wrote about New Mexico, "This land of poverty for the Conquistador was a land of wealth in souls for the Franciscans." This statement cemented New Mexico's entire purpose in the eyes of the Spanish crown.

In the late 1600s, the harsh attitudes of some of the Spanish explorers toward the native people would prove to be their downfall as many Pueblo revolts occurred in an attempt to rid the land of Spanish influence. This in turn created new setbacks in the establishment of a Christian society as well as in the production of wine.

Determination

The first obstacle, however, arose from Spain itself in its attempt to control the revenues from the sales of wine and prevent the ruin of the Spanish agriculture industry. Grape production was a major source of income for the Spanish crown, being one-fourth of its foreign trade revenue. Spain, therefore, passed a law in 1595 that strictly prohibited growing grapevines in the New World, leaving the monks no choice but to abide by the law and wait for the shipments to come from Spain via Mexico.

Spanish sacramental wine was traditionally made from the *Vitis vinifera* grape, better known today as the Mission grape. It produced a light pink wine with a sherry taste that was 18 percent alcohol and 10 percent sugar. In order to transport the wine to the New World, it was placed in an amphora, a two-handled earthen jar with a cork or wood stopper. Each amphora held about two and a half gallons.

Today, as Spanish shipwrecks have been discovered, mainly along the eastern seaboard and in the Gulf of Mexico, many of these green lead–glazed vessels have been plucked out of the sea still containing their precious cargo, although drinking this bounty is highly discouraged.

During colonial times in Mexico, the city of Parras had become the center for fine wine production, a distinction it enjoyed until the latter part of the eighteenth century when the competition from the New World wines increased. Grapevines, introduced to the area around Parras by Jesuit priests in 1597, flourished, and the residents ignored royal orders not to produce wine—so much so that by the early part of the eighteenth century, 900 barrels of aguardiente, or brandy, and 250 barrels of wine were delivered to the miners of Zacatecas alone.

Wine became one of the most highly sought-after imports in all the regions of New Spain. Used daily in religious contexts by the Catholic clergy, wine was held in high reverence. On the other side of the spectrum, it was also an ingredient for some potions used by local healers, who were considered witches by the clergy at the time.

In spite of high demand throughout New Spain, wine shipments were slow to arrive. For example, the transportation time to receive the wine by ship from the Spanish ports was approximately three long years. The wine first traveled from the ports of Vera Cruz through Mexico from Parras and then along the Rio Grande Valley by burro cart to Senecú, a Piro Indian pueblo south of present-day Socorro in central New Mexico.

With the total yield of this journey being only a miniscule forty-five gallons of wine, Franciscan monk Fray García de Zúñiga and Antonio de Arteaga, a Capuchín monk, knew they had to take matters into their own hands. To supply the growing number of mission churches along the Rio Grande that needed wine for their daily Masses, the friars had to be thrifty with the four gallons of allotted wine.

In defiance to the Spanish law and in order to save the church a great deal of money, the priests imported vines from southern New Mexico and Parras, Mexico, because they were in proximity. This is contrary to the persistent rumor written in so many accounts that states the priests, at their own peril, secreted vines out of Spain to be planted in the New World. Wine historian and Ponderosa Valley Vineyards and Winery owner Henry Street explains that although the rumor is a romantic legend filled with drama and danger, the reality was purely an economic one.

The Mission grapevines flourished in the rich soil of the New Mexico Territory where they were planted, taking firm root and catapulting New Mexico into the fifth-largest wine producer in the nation by the late 1800s, despite the occasional hard freeze in the northern regions. The Jesuit priests, who arrived in 1868 and settled in the Santa Fe area as well as southern New Mexico, brought with them their Italian winemaking knowledge. They prompted plantings in the southern region of New Mexico around the Deming/Las Cruces area, where the locals swear by the perfect grape-growing climate.

By 1870, New Mexico had produced sixteen thousand gallons of wine. This amount increased dramatically to nearly one million gallons by 1884. This increase gave the territory the coveted bragging rights of having twice the amount of grapevines than the much more developed state of New York.

Small vineyards sprang up all across the territory as farmers saw the literal fruits of their labors—grape clusters larger than a man's hand—winning top prizes at the local and national levels. Newspapers were exalting the lowly grape as the new moneymaking wonder crop. It was, but with one problem: lack of transportation.

Being quite isolated, New Mexico farmers depended on the railroad to transport their crops to other markets, an extremely expensive proposition in the early days. The risk, time and money it took to produce a crop only to have it ruined as it languished at a train depot was devastating to many farmers. To prevent these disasters, the grapes were kept for use within New Mexico borders to feed the hunger of the growing statewide wine industry. If it were not for the isolation, the New Mexico wine industry would surely have grown more rapidly.

STRUGGLES

The New Mexico wine industry continued to develop in the 1800s until its near demise in the early twentieth century. The reason: Prohibition.

The temperance movement had always had a strong hold in the Land of Enchantment, which passed its own statewide prohibition in 1917, two years before the national law came into effect. As a fledging state of only four years, New Mexico had already seen its share of trouble with the American Temperance Society, the Woman's Christian Temperance Union and the Anti-Saloon League in the major populated cities of Albuquerque and Santa Fe.

As with the restrictions of the Spanish crown, New Mexicans once again were forced to become creative in their methods to continue winemaking while trying to adhere to the law of the land. These fascinating stories will be brought to light. It is safe to say that sacramental wine once again became a hot commodity. Because the law allowed a small amount of medicinal alcohol to be produced and sold, the sale of wine was diminished, but the acreage of grapevines actually doubled during the Prohibition years.

The Flood

Although the fertile wine-growing soils of the Rio Grande Valley played host for many destructive floods, true devastation came to these grapevines in 1943 when a one-hundred-year flood occurred. It was the largest flood the Rio Grande Valley had ever seen. The raging waters tore a path of destruction through the valley so wide that the entire commercial wine industry in New Mexico was never to fully recover.

The population along the Rio Grande had risen during this time; therefore, the demand for water also rose, creating the need for ditches, canals and irrigation, which disrupted the natural ability of the river to release sediment. This in turn formed clogs along the river, raising the water table and basically turning the farmland into swampy marshes. When the flood came, it took everything with it downstream. It is written that none of the original grapevines survived in the vineyards due to root rot and alkaline deposits, but if you look close enough, you can still find a feral vine along the roadside from time to time.

Triumph

It wasn't until 1977, with the birth of La Viña Winery in La Union, New Mexico, that the wine industry started anew. Once again along the Rio Grande Valley, cold-hardy French-hybrid varietals were planted in the hopes of reviving a long-loved and revered wine industry. With over fifty-four wineries in New Mexico today, and a production rate of almost 900,000 gallons, it is safe to say wine has returned with gusto!

Come along on a delectable journey through the Land of Enchantment as we explore the four very different grape-growing regions and the delicious wines they produce. Drink in the unique history of the wineries and the passionate families who own them while savoring the matchless beauty that is New Mexico.

Vitis Vinifera

Grape on a Mission

As wine grapes come to mind, one might think of the Zinfandel, Chardonnay and Merlot varietals as the more noble grapes. Though a common grape in the *Criolla* and *Monica* grape families, and largely unattainable in the United States today, the Mission grape forged itself a huge place in history when it hit Californian soil.

Spanish scholars from the Centro Nacional de Biotecnología in Madrid uncovered the origin of the Mission grape, which was the earliest European vine grown in the western hemisphere. The true heritage of the Mission grape was in question by scholars who believed the Mission grape ended in Spain when phylloxera (a pest that feeds on the roots and leaves of grape vines) destroyed much of the Spanish viticulture in the nineteenth century.

The Mission grape has now been linked by scientists through DNA tests with the red País grape, which originated from Chile, as well as the pink Criolla grape of Argentina and, more importantly, the rare Spanish variety called the Listan Prieto. Listan is also known as Palomino, a primary white grape used to make sherry, while *Prieto* translates as "dark" or "black."

Widely cultivated in the Castile region of Spain during the sixteenth century, the Mission grape served as the workhorse of grapes. Flourishing in warm climates, the Mission grape was known to produce a crop of more than ten tons per acre when it ripened in mid- to late season.

The Mission grape clusters grow as large as a man's hand and form loosely filled bunches, which allow for the fruit to mature longer on the vine,

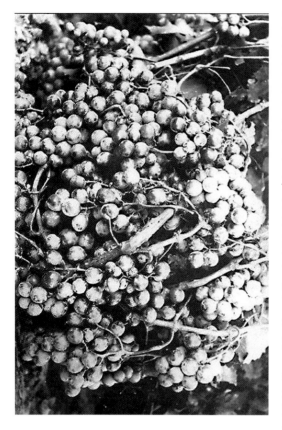

The large, dense clusters of the Mission grape provided not only the necessary wine provisions but also a good income for growers. *Courtesy of the Southeastern New Mexico Historical Society*

thus developing high sugar levels. Importantly, these loosely filled clusters also help protect the fruit from mildew and rot. Grapes are the only fruit capable of producing the right amount of nutrition for yeast on their skin and sugar in their juice to ferment naturally. All of these good features have lent a hand in making Mission grape the most long-lived fruit of the vine, as well as the oldest cultivated grape in the United States. In fact, some mother vines reach well past the century mark.

Thick-knuckled vines with strong canes can be grown from seeds or rootstock. Most commonly grown in structured, cultivated rows, the grapevines do well in the sandy soil along the Rio Grande, which bisects the state of New Mexico. The Mission grape was especially prized by early wine growers because it is a hardy stock. The grapevines can withstand the many weather changes that New Mexico so eagerly provides. An old saying in the state goes something like this: "If you don't like the weather now, wait five minutes and it will change." Seemingly oblivious to neglect, precious few remnants of the ancient vines can still be found scattered across the state along ravines, in private backyards or scaling old adobe ruin walls.

It is such a vine that vintner David L. Wickham of the Tularosa Vineyards found to start his personal revival of the heritage grape. Being one of only three wineries in the entire state that features a wine made from vintage Mission grapes, Tularosa Vineyards is proud to keep the tradition of early Spanish settlers alive.

David Wickham, owner of Tularosa Vineyards in Tularosa, New Mexico. *Courtesy of the author.*

Wickham took a cutting from the one-hundred-year-old vine growing in the backyard of La Luz resident Ben Chavez in 1989. The vine was started in a quarter-acre vineyard located in Wickham's own Tularosa backyard.

Careful pruning and a good water source are the keys to good grape production. A small cane cut from the mother vine in the winter is replanted in the spring, thus constantly replenishing the stock. It is said that the vine

educates the soil. Wickham stated that it is nearly impossible to purchase Mission grapevines now, and without his cultivation, the grape might have been "lost forever in historic obscurity because undoubtedly it is the oldest variety here in New Mexico."

Tularosa Vineyards is planning to increase its Mission grape acreage so this light pink, semi-sweet wine made by his winemaker son, Chris Wickham, can be enjoyed for many generations to come.

Entrada

In the sixteenth century, Spain was one of the most powerful countries in the world. As with all countries, the need for new land and new opportunities for commerce drove it to explore the New World. Mexico was already under the rule of the Spanish crown by 1519, but greed for gold spurred the Spanish forward to seek out riches in a wild and untamed land known as *Nuevo México*.

With the exception of Florida, New Mexico is the oldest state name in the United States. The name is attributed to Francisco de Ibarra, who in 1565 proclaimed the land north of Mexico as *Nuevo Méjico*.

Fantastic stories of seven cities made purely from gold piqued the interest of not only Spain but also the Spanish settlers living in Mexico. With its coffers extremely low due to disastrous, expensive wars, Spain was in desperate need to replenish the treasury. King Phillip II, by royal decree, authorized the settlement and pacification of the new land. In a letter written by Sabastián Vizcaíno in November 1598, it was reported—although thought likely to be exaggerated—that there were sixty thousand pueblo residents living in New Mexico at that time.

Six expeditions were launched into the bowels of the unknown land, all fueled with promises and dreams of great riches only to be met for the most part with disappointment and anguish. Encounters with the native people caused a great deal of wariness between cultures as each had previously seen and not forgotten the good and bad sides of the other.

By 1598, when Don Juan de Oñate, the son of an ultra-wealthy silver baron from Zacatecas, Mexico, had found his way deep into the Rio Grande Valley, the people who occupied the many pueblos along the river had already seen the ill effects of new explorers on their society from past expeditions and were not eager to welcome the next wave.

In need of supplies, Oñate demanded that the Acoma Pueblo people surrender theirs. When Acoma refused, stating its supplies were all it had to survive the winter, Oñate declared war on the pueblo. During this war, Oñate's nephew was killed, and in retaliation for his death, Oñate ordered the amputation of the left legs of all Acoma men over the age of twenty-four.

Acoma Pueblo, called the "Sky City," is a village built on top of a tall mesa that is accessible only by foot. Known as runners, the Acoma Pueblo men were humiliated by Oñate's actions, not to mention the hardships placed on them by the amputations.

A statue was erected in Oñate's honor amidst the protests from the native people. From time to time, this statue will mysteriously be missing its left leg.

Viewed as heathens in need of being saved from their godless ways by the eleven Franciscan friars who accompanied Oñate on his journey, the native people were enlisted, oftentimes by force, to construct strange buildings in honor of an even stranger god in the middle of their own communities. It was by these means that the mission churches were built.

The Franciscans wrote to their dioceses about the amazing progress they enjoyed in the conversion of the savages to Christianity. Unbeknownst to the clergymen, it was said that while the natives were good Catholics attending church, they still practiced their traditional rituals at home. The use of prayer sticks, maize and kachinas by the native people was punishable by death if discovered once the Spanish Inquisition was in full swing in the New World.

Oñate's expedition to colonize the northern territories began in January 1598, after three years of largely self-funded preparation. It was a risky journey as it included close to five hundred soldiers, about half of whom also brought their families; five priests; seven thousand head of stock, mainly sheep; eighty-three carts; and twenty-six wagons to carry provisions. The wagon train was reported to be nearly three miles long as it made its way northward.

Oñate started in Santa Barbara, Mexico, but rather than following the typical route taken by previous conquistadors along the upper Rio Conchos, Oñate chose to veer off to take a straighter route through the Chihuahuan Desert. In hindsight, this almost caused the demise of the entire troop due to the intense heat and rain faced by the party, as well as lack of supplies forty-five days into the fifty-day trek.

Oñate's route was to become the beginning of the *El Camino Real*, the "Royal Road," and the major trade route from Mexico to the New World.

After five days of trudging without water through the desolation of the Chihuahuan Desert, along what is known as the *Jornada del Muerto*, loosely

translated as the "Route of the Dead Man," the Spaniards' mastiffs and greyhounds caught a welcome scent. The Rio Grande showed itself to the travelers as mayhem ensued. Horses and men alike plunged into the life-giving liquid, drinking in the substance, which at that moment was far better than the gold they were seeking. Written accounts state that several of the horses overindulged on the water to the point of causing their stomachs to literally explode.

It was at this spot, close to modern-day El Paso, Texas, where the second Thanksgiving of the New World took place. On April 30, 1598, twenty-three years before the Pilgrims set foot in Plymouth, Massachusetts, the grateful Oñate explorers held a Mass of Thanksgiving followed by a banquet of fish and fowl. This was also the day when Don Juan de Oñate formally took possession of the new land and declared it to be named New Mexico in the name of God and the Spanish king. (The first actual recorded Thanksgiving is said to have taken place in St. Augustine, Florida, among the Spanish and the Timucuan Indians on September 8, 1565, some fifty-six years before the *Mayflower* made land off the coast of New England.)

Coincidently, Thanksgiving Day is the American holiday when the most wine is consumed. In New Mexico, the typical Thanksgiving Day feast will include tamales and enchiladas. New Mexicans have been known to pair Tempranillo wine with this fare.

Settlement

Traveling nearly the entire length of what is now New Mexico, Oñate's group decided to first settle in Ohkay Owingeh Pueblo, which was thirty miles north of the present-day state capital, Santa Fe. The Spanish renamed the pueblo San Juan de los Cabelleros. San Juan was the first permanent colony in New Mexico, second in the United States after St. Augustine, Florida, and was also the location of the first Spanish irrigation ditch construction, which began August 1, 1598.

Soon after arriving, Oñate's group moved across the Rio Grande River to Yunge Owingeh Pueblo, which Oñate renamed San Gabriel de Yunge. San Gabriel became the first European capital of the New Mexico Territory. (Santa Fe became the capital of the Spanish Colonies of New Mexico twelve years later in 1610, therefore becoming the oldest capital city in the United States.)

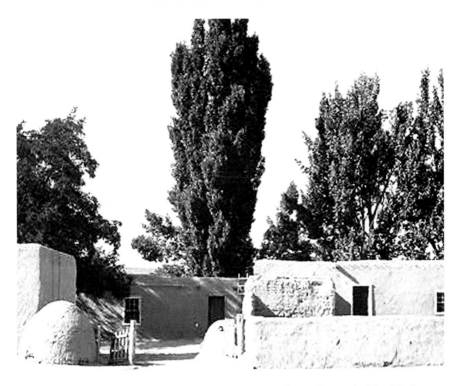

San Gabriel de Yunge, the Tewa pueblo that became the first settlement in New Mexico, established by Don Juan de Oñate and the site of the first Spanish capital in the New World. *Courtesy of the Southeastern New Mexico Historical Society.*

To establish the colony's new capital, Oñate and his followers basically forced the native inhabitants of Yunge Owingeh Pueblo to move to Ohkay Owingeh Pueblo and redecorated the four-hundred-apartment pueblo to better suit the tastes of the Spaniards. It was during this time that the pueblo was fitted with wooden doors and window frames.

Also during this time frame, the Pueblo Indians began to suffer more ill effects of Spanish rule. The local Spanish government imposed a tax to be paid in goods such as corn and blankets. Many Pueblo Indians were forced to work in the Spanish fields, which were once their own, and their traditions, including all religious rituals, were banned by the church, resulting in many of the religious leaders of the Pueblos being jailed for their views.

By the time the natives finished working in the Spaniards' fields, there was little time to work in their own fields, lowering yields and causing great hardships among the tribes, especially in their ability to pay the imposed taxes. Wild grapes, used by the natives as medicine, were also frowned upon

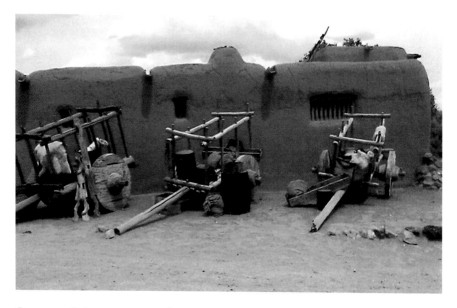

Ox carts, called *carretas*, were used to transport supplies, mostly wine, to the settlers. *Courtesy of the author.*

by the new arrivals because of the previously mentioned wine-growing restrictions by the Spanish government.

The Spanish settlers were having troubles of their own. Being so far from Mexico, supplies from home were valuable and extremely hard to come by. One of these supplies was the all-important sacramental wine essential to the completion of their mission of conversion. Wine, supplied by the Spanish crown, had to travel by oxcart six months to reach the Franciscan monks who were now located one thousand miles from the source location in Mexico.

Because wine was a staple of everyday life in Mexico, both for daily and ecclesiastical use, a law was enacted in 1521 by Hernán Cortés, known as the discoverer of Mexico, conqueror of the Aztecs and an agriculturalist. It was Cortés who established the first leg of the El Camino Real and stated that each Spaniard must plant one thousand vines for every one hundred natives in service to them on the land they were granted.

Roughly seventy years later, in 1595, seeing a cut in exportation, King Phillip II of Spain strictly prohibited all wine production and grape growing in the New World because these products were huge revenue producers for his country.

The main intentions of the conquistadors were to, first, find gold and riches for the Spanish treasury and, second, bring the way of God to the native

people. The most vital feature of the Catholic faith is the daily celebration of the Holy Mass. The priest must have certain important elements to perform the Eucharist—namely bread and wine. The Communion wafer could be easily obtained, but it was the sacramental wine, which represents the blood of Christ, that was the precious commodity.

As it is considered a sin to dilute sacramental wine with water, except for the three drops representing the Holy Trinity added by the priest during Mass, the monks were forced to ration their allotment as best they could, for they knew it would take three years between shipments.

One can only imagine the taste of this wine as it reached its destination following a sea journey and a long trek across the Chihuahuan Desert in the intense heat. This, of course, is not including the distinct probability of lead poisoning caused by the leaching from the ceramic glaze used inside the clay vessels or amphora. The Romans actually added lead to their wines to make them sweeter, a practice that ultimately caused widespread lead poisoning.

As the enormous costs of wine transportation to the new colonies mounted and threatened to bankrupt not only the church but also colonial governor Francisco Manuel de Silva Nieto, it was largely decided to ignore the ban, especially in the more remote areas of the kingdom, namely New Mexico. The threat of excommunication from the Catholic Church given by Pope Clement VIII in solidarity with the priests in New Spain also quickly encouraged the Spanish crown to loosen its tight reins on its farthest outreaches.

FIRST PLANTING

The Mission grape, *Vitis vinifera*, was first introduced to the sandy New Mexican soil in 1629 by Fray Garcia de San Francisco y Zuñiga and Antonio de Arteaga at the San Antonio de Padua Mission in Senecú Pueblo for the purpose of producing sacramental wine. Grown within the courtyard of the church, most likely the first vines clung on arbors tended by the priests and natives who lived and worked at the mission.

As an interesting side note, Fray Zuñiga, who was founder of the missions of El Paso, Texas, is also given credit for establishing the Mission grape vineyards in 1650 in that city, thus starting Texas on its own wine journey. The mission church he built, Nuestra Señora de Guadalupe, still exists in Juárez, Mexico, and is the oldest structure in the El Paso area.

Full wine production, although primitive, began in 1633, a few years after the first plantings at Senecú, and was successful for forty years, providing an adequate wine supply for all of the other missions in New Mexico until unrest in 1675 among the Apaches who lived in the region resulted in numerous raids in which all of the priests and some of the native people were slain. After the raids, Senecú was abandoned, with its inhabitants moving to other pueblos in the area.

The writing was on the wall with the first Indian attack along the El Camino Real. By 1680, the Pueblo people had endured much abuse from their Spanish occupiers. Word was spread by means of a knotted rope, which signified the number of days to wait to rise up against the Spanish and retake their homes.

The result was the Pueblo Revolt of 1680 in which more than 400 Spaniards were killed and the remaining 2,500 driven to Mexico from the northern pueblos that remained after the destruction of Senecú. All traces of the Spanish way of life were ordered burned, destroyed and buried. This is why much is unknown about this period, as many of the books and papers written by the missionaries were obliterated by the raiding parties.

The native people would enjoy a twelve-year stint without Spanish rule until the reconquest of New Mexico by Don Diego José de Vargas Zapata Luján Ponce de León y Contreras in 1692, better known in history as Don Diego de Vargas. One of the first orders of business in this "bloodless" reconquest was to replant grape vines throughout the entire reconquered kingdom.

The Vargas expedition was met with some resistance as the memories of past struggles were still fresh in the minds of the pueblo inhabitants. There was unrest and many more unorganized revolts throughout 1696, after which most of the pueblos submitted to Spanish rule.

Large vineyards containing ten thousand to twenty thousand grape vines were attached to San Antonio de Padua, a hacienda located only a few miles from the original Senecú and owned by Antonio de Valverde Cosío, who served as a secretary for Diego de Vargas in 1693. It is also said that Valverde had another five thousand vines on his ranch in El Paso, Texas.

Fray Miguel de Menchero, in a report on his visitations to New Mexico missions in 1694, wrote, "[The missions] take out acequias to irrigate the wheat and vineyards, which are very abundant, and they harvest fruit of good flavor and a rich wine that is in no way inferior to that of Spain."

However, it seems Menchero may have embellished his claims a bit as his superiors had a different perspective. Being greatly interested in the

profitability of the wine, the authorities criticized it for its low quality in order to make the Spanish wine more appealing to the public. The Catholic Church was a huge recipient of the spoils from the wine industry in New Mexico, as it received tithe payments in the form of wine. Many dioceses were known to have large storage facilities called *bodegas*. These housed copper kettles, skimmers, funnels, wheelbarrows, hide vats and pressing troughs, along with other items one could use to produce wine, though most likely they were never used.

As wine and brandy production grew, the value also rose, spurring more local farmers to begin growing grapes to meet the demand and cash in on the profits.

By 1766, the Spanish crown had ordered an inspection tour of New Mexico by Franciscan friars to examine the fortified Spanish military bases, called *presidios*, and report on the deterioration of the Spanish rule. Heading this tour was Cayetano Pignatelli, third Marquis of Rubí, a Spanish nobleman and military leader who played a key role in determining Spanish policy toward Texas and Mexico. Also along for the inspection tours were royal engineers Nicolas de La Fora and Joseph de Urrutia, who produced hand-drawn plans and maps of the regions.

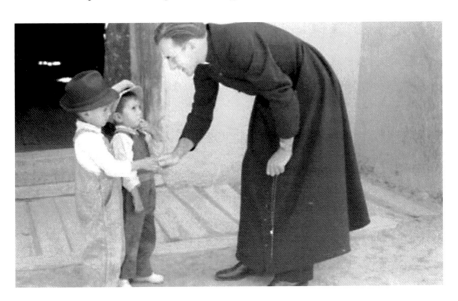

A Franciscan friar carries on the long tradition of service to parishioners in New Mexico churches. The Franciscan Order was founded by St. Francis of Assisi about 1209. Since its founding, the Franciscan Order has been one of the most highly recognized religious orders in the world. *Courtesy of the author's collection.*

In a recently translated diary kept by Nicolas de La Fora, he wrote how impressed he was with the quality of the New World grape, which he described as being "in no way inferior to those of Spain." This sentiment mirrored the words of Fray Menchero. The grapevines that had seen so much turmoil had truly taken root in the rich soil of New Mexico. It is notable that it was around this same time in 1769 that the wine industry in California began with the Mission grape, nearly 140 years after the first New Mexico plantings.

Responsible for forging the Old Spanish Trail, an important trade route that connected Santa Rosa de Abiquiú, near Santa Fe, New Mexico, with Monterey, California, Fray Francisco Atanasio Dominguez and Fray Silvestre Vélez de Escalante kept diaries of their travels. In these diaries, they wrote of their discoveries of large lime and lemon groves in northern New Mexico. Vineyards in the northernmost regions of New Mexico around the Santa Clara Pueblo, he recorded, were taking hard hits of floods, severe cold and pest infestations from Mother Nature. This would remain a trend in New Mexico's wine history.

According to New Mexico state historian Rick Hendricks, colonial New Mexico had no monetary system during the sixteenth- and seventeenth-century time frame, so wine and brandy became valuable items for bartering. Loans or credit were given on the prospects of future crop yields and wine production.

In the late 1700s, the wine industry was on the cusp of emergence into a force to be reckoned with, not only in New Mexico, but also throughout the nation. At this time, wine grapes ranked number one among the world's fruit crops in terms of acres planted.

Century of Turmoil

1800s to 1900s

In the nineteenth and twentieth centuries, turbulent events continued to form the history of what we know as New Mexico today, but during it all, the wine industry rocketed forward. With the planting of vineyards, Ponderosa Valley Vineyards and Winery owner and wine historian Henry Street reports that by 1800 grape vines were being grown in abundance from Bernalillo, New Mexico, all along the Rio Grande to El Paso, Texas, creating a huge source base for a booming wine industry. Wine is listed as one of the top three exports from New Mexico in 1804, along with wool and animal pelts, with a combined value of $60,000.

Reports on the New Mexico Territory exalted its agricultural virtues. The production of brandy and wine in the El Paso region, otherwise known as Pass Brandy/Wine, flourished, and the vintage became a favored export along the El Camino Real. Mesilla Valley and El Paso, Texas, both became known for their full-bodied wines, which rivaled any in the world.

The virtues of Doña Ana County, in which the cities of Las Cruces and Mesilla lie, were expounded by historical newspapers, which stated that the county had acquired a "high reputation for her vintage, the vineyards yielding from 1,300–1,500 gallon per acre." The Mesilla Valley is the first portion of New Mexico to attract the attention of the Anglo-Saxons for settlement.

"In the garden and vineyards [of Doña Ana County], the finest fruit of the temperate zone reach perfection," reported the *El Paso Herald*.

The Mission grape was turning heads in the Tularosa Basin in Otero County and, finally, in the Mesilla Valley—enjoying the warm, dry days and cool nights with a vengeance. These are still two of the largest grape-growing regions in the state, and they continue to expand.

George B. Anderson writes about the Mesilla viticulture in his book, *History of New Mexico: Its Resources and People*:

> *The vineyards of this valley have long been famous. For a long time they were composed entirely of the Mission grape, but a large number of other foreign varieties have been introduced with great success. These include the Muscat of Alexandria, Flaming Tokay, Rose of Peru, Gros Coleman* [sic]*, Cornichon, Black Burgundy, etc.*

The town of Mesilla was chiefly noted for its magnificent orchards and vineyards, its streets being regular and lined with beautiful shade trees. Besides fruit and wine, its principal resources are hay and grain raised in the surrounding districts. An abundance of water is obtained by means of irrigation ditches from the Rio Grande and from driven wells, which are dug thirty to fifty feet into thick sand and gravel deposits when the ground water is within fifteen feet of the surface.

Nearly every county along the Rio Grande Valley in New Mexico could boast a wine industry as well established as Bernalillo County, which turned heads in the early days as it does today. It is said that the Rio Grande Valley is the principal agricultural valley. Most of the vineyards were located in the lower plane, formed entirely of alluvium, which contains loose river sediments filled with clay and silt deposited by a running river. This soil is very fertile and is considered to be high quality for wine growing because of the low levels of magnesium.

In a good year during the 1800s, a yield of 1 to 1½ gallons of wine per vine could be produced. Vines were planted eight feet apart each way, giving 680 vines to the acre with a low-estimate yield of 1,360 gallons. Larger fruits, such as cherries, plums, apricots and apples, did not show up in the county for twenty years after the grapes because of climate conditions.

According to a report by the State Farm and Livestock Bureau in 1907, the town of Bernalillo is located "in the midst of a broad valley of rich alluvial sand largely devoted to the production of grapes and fruits, as well as agriculture products. Wine-making, fruit culture, and wheat raisings are the representative industries." The major industries of

A dramatic view of the Rio Grande Valley. *Courtesy of the author's collection.*

Bernalillo County were raising sheep and winemaking for the sixty-four families who lived there in the early nineteenth century.

In Valencia County, the report notes, "peaches and grapes are the staple fruit crops; there are single farms that yield tens of thousands of pounds of the Mission grape."

Valencia County had a high reputation early on among connoisseurs of wine and brandy for using only the finest fruit for distillation of its brandy and producing wine from pure juice without artificial sweetening. In order to satisfy those who prefer a very sweet wine, the vintners took the unfermented grape juice and boiled the liquid down to thick syrup. This liquid, called Angelica, was added to the wine as a sweetener.

Lincoln County—the adoptive home of William H. Bonney (or, as he was better known, "Billy the Kid") and site of one of the most turbulent events in New Mexico's history, the Lincoln County War—was also known for its grape production.

"Grapes and currants in their native state grow in abundance, while cultivated vines as well as apples, peaches and pears yield splendid harvests," stated Max Frost, Secretary for the Bureau of Immigration.

Today, Lincoln County is famous more for its apples.

Otero County, sister to Lincoln County, is the home of numerous modern day vineyards and wineries. Attributed to high amounts of iron in the rich, deep clay subsoil, grapes from Otero County are of the finest quality. James C. Dunn of Alamogordo, in Otero County, began raising grapes in 1900. He was the first man in the territory to implement dry farming for the production of fruit. Originally from Gloucester, Massachusetts, Dunn used the Campbell System on his farm, though there is no record of how successful he was in this method.

The Campbell System, developed by Hardy Webster Campbell of Kansas, was making headlines in 1900 with its dry farming method. In this method, one obtained as much rain storage in the soil as possible (Campbell believed the rain would follow the plow.) A farmer would plow deep using a subsurface packer, virtually creating a type of "dust mulch." Campbell's mottos were: "Don't pray for rain, use the water you have" and "Don't try to change nature's laws to fit your own methods and habits. Change your notions and habits to conform with nature's ways."

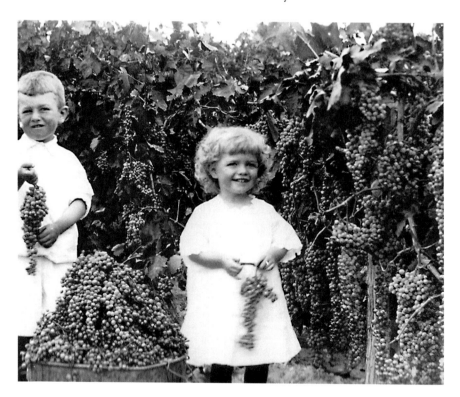

Children of Eddy County with large clusters of grapes. *Courtesy of the Southeastern New Mexico Historical Society.*

At the opposite end of the state from Otero County, in the far northwest corner, sits San Juan County, which in 1907 had forty thousand acres of fruit land. Besides Mission grapes, the foreign varieties succeeded beyond expectations; even the seedless Asian Sultana grape ripened to perfection. Garden farming methods, such as planting in rows instead of using arbors, were used to a successful end in grapes grown in that region.

When visiting this region in the early 1500s, Antonio de Espejo described the area along the Pecos River as "abounding in great mineral wealth, good grazing country and land suitable for fields and gardens, with or without irrigation." Espejo's report was instrumental in the settlement of the new province.

In the far southeastern corner of New Mexico is Eddy County, which is along the Pecos River. Charles Greene, one of the founding fathers of the city of Eddy (now Carlsbad), New Mexico, planted the first grapes in the county in 1893. By 1897, grape shipments were being made from Eddy (Carlsbad) almost every day.

The local newspaper, the *Eddy Argus*, reported that E.G. Shields, the general manager for the Pecos Irrigation and Investment Company, had begun to receive his grapevine cuttings from France in 1890. There was no word on his success. The same newspaper also wrote, "This valley is destined to become the finest vineyard and orchard area in America. The *Argus* will soon begin calling the Pecos Valley—'The Fruit Belt.'"

Unrest

As part of the Louisiana Territory, the New Mexico Territory saw much unrest among the native tribes such as the Apache and Comanche, who traveled along both the Rio Grande and Pecos River. Indian raids struck fear in the hearts of the Spanish and Anglo-American settlers who were trying to set up areas of communication and transportation. The Comanche would eventually join with the Spanish against the Apache, beginning many years of strife between the two tribes.

The Louisiana Purchase of 1803 opened the West to more exploration by Anglo-Americans. In 1807, Zebulon Pike, a lieutenant with the United States Army, was one of the first Americans to travel through the Mesilla and El Paso Valleys, which were producing large quantities of wine under Spanish direction.

Pike wrote:

The grapes, carefully dried in the shade make excellent pasas or raisins, of which large quantities are annually prepared for market by the people of that delightful town of vineyards and orchards, who taken altogether, are more sober and industrious than those of any part of Mexico I have visited, and happily less infested by the extremes of wealth and poverty.

The Comanche became a formidable concern for the Spanish settlers as their increased raids on the small communities occurred more and more frequently in the early part of the 1800s. Horses, which had been introduced to the native tribes by the Spaniards, were highly valued and were constantly being taken in raids on settlements by nomadic tribes—first for food, as horsemeat was considered a delicacy by the native people, and later for invaluable transportation.

These raids resulted in a drastic drop in trade along the Rio Grande Valley region, so much so that wine was the only revenue-producing product. Because most communities along the valley had producing wineries and vineyards, the need to transport the product was alleviated. It is reported that New Mexico wineries had an annual production of 1,600 gallons.

Go West Young Man!

The Santa Fe Trail, established in 1821 by William Becknell, was a center of trade between the eastern states and Mexico and Mexican California in 1830, proving its worthiness to the United States. Becknell would return to Franklin, Missouri, with bags full of Mexican silver pesos, which he received for selling his wares, exciting eastern merchants with the prospect of creating a lucrative trade route. Many merchants used Santa Fe as the point of contact with business partners bringing a greater economic prominence to New Mexico and eventually leading to the economic downfall of central Mexico.

Deep ruts made by heavy-laden wagons left permanent scars on the New Mexican landscape. The results of the massive migration can still be seen along the roadside in northern New Mexico today, especially in the region near the towns of Las Vegas and Fort Union, which were points of contact for the travelers. Both of these communities had saloons frequented by the

troops, who would partake in native wine, a vintage cheaply made from the locally grown Mission grapes.

This was a period of great commercial growth. The imposition of customs duties on all the wagonloads of goods brought into the New Mexico Territory from Mexico undoubtedly brought with it a certain amount of criminal intent in the form of bribery and embezzlement from traders who found ways to smuggle a good deal of their cargoes to avoid the fees.

The New Mexico Territory found that its most serious problem during the Mexican period was the lack of adequate funds to maintain the barest of governments. By 1846, rumors of war between the United States and Mexico had caused greater strife in New Mexico. After the declaration of war by James K. Polk, Brigadier General Stephen Kearny led the Army of the West out of Fort Leavenworth, Missouri, for the conquest of the New Mexico Territory and California.

Kearny's forces met the opposition of Governor Manuel Armijo, who admitted defeat in August 1846. As a result, the Army of the West marched into Santa Fe and replaced the Mexican Republic colors with Old Glory over the Palace of the Governors. It was by the actions of acting governor Juan Bautista and Vigil y Alaríd that the New Mexico Territory was officially surrendered to the United States.

In 1848, by means of the Treaty of Guadalupe Hidalgo, which ended the war with Mexico, the New Mexico Territory became part of the United States, and the United States gained the Rio Grande boundary with Texas and the state of California in the deal. The treaty also allowed Mexican citizens of the large area, including New Mexico, Arizona, Colorado, Utah, Nevada and parts of Wyoming, to become full citizens should they so choose.

Nature played a huge part in the development of New Mexico, and despite the report of many earthquakes that rattled the Socorro area and caused damage to structures, many vineyards were observed in 1849 by army surgeon John Fox Hammond:

> *Vineyards, fields of wheat and corn, and peach orchards surrounded the village. An acequia* [ditch] *leading from the springs to the village furnished water for the gristmills, for home use, and for irrigating the fields and vineyards.*

The gold rush officially began in 1849 in California, but the first vein of gold to be found and worked west of the Mississippi was the Sierra de Oro (Mountain of Gold) or the Ortiz Mine near Santa Fe in 1833. As a result of

these discoveries, the New Mexico Territory saw thousands of travelers on the Santa Fe Trail on their way to the California gold fields. Supplies were bought from local merchants in New Mexico, including native wines made from the Mission grape that were being grown in the Albuquerque area. By this time, the Rio Grande Valley wineries were producing fewer than ten thousand gallons of wine as local farmers were devoting only one or two acres of arable farmland to grapes.

STATEHOOD STRUGGLES

New Mexico became an organized incorporated territory of the United States on September 9, 1850, through the Compromise of 1850, which brought with it protection and access to some of the governing laws of the nation. This was also the first year New Mexico applied for statehood and was turned down, although it met both of the requirements for a territory to become a state: a population of over sixty thousand and a written constitution. The only drawback was that its request also had to be approved by the United States Congress in a majority vote. New Mexico was made to wait another sixty-six years before it would finally achieve statehood on January 6, 1912, which proved to be a purely political move.

In 1850, the United States Congress organized the lands east of the Rio Grande as part of the New Mexico Territory and paid the State of Texas $10 million for these lands.

The Gadsden Purchase, or the Treaty of Mesilla, ratified in Old Mesilla on November 16, 1854, facilitated the purchase from Mexico of 29,670 miles of land mostly in modern-day Arizona and southwestern New Mexico and officially made Mesilla part of the United States, opening a direct route for commerce. The vineyard of T.J. Bull, which is now the Double Eagle Restaurant, played host to the signing. Mesilla was then the first territorial capital of New Mexico.

The famous La Posta Restaurant in Old Mesilla features a "grape room" that is modeled after the natural grape arbors of Seville, Spain. Originally, La Posta was a stage station on the Butterfield Trail. It is now the only stage stop that is still in use and is one of the oldest, most historic buildings in Mesilla while still paying homage to the rich grape traditions of the Mesilla Valley.

It was tradition during this time to allow one to two acres of land to be planted with grapes, which could yield three tons of grapes per acre at

harvest. With only five thousand farms existing in the Rio Grande Valley due to the fact that most farming was by subsistence, only a small fraction of land was utilized.

William Davis, an attorney for the territory, wrote in 1853:

> *No climate in the world is better adapted to the vine than the middle and southern portions of New Mexico, and if there was a convenient market to induce an extensive cultivation of the grape, wine would soon be one of the staples of the country, which would be able to supply a large part of the demand in the United States.*

In 1854, as Davis toured New Mexico through the Bernalillo area, he also wrote, "At Bernalillo we enter the wine growing region of New Mexico which extends south to El Paso. Grapes of superior quality are cultivated, several thousands of gallons of wine are made yearly for home consumption and little gets to market."

During the nineteenth century, citizens of New Mexico saw many historic yet ultimately violent events unfold, including Indian wars and revolts, the assassination of Governor Albino Perez in Santa Fe, an invasion by Texas, smallpox epidemics, the Mexican-American War, the United States Civil War, the Spanish-American War, the surrender of Geronimo, the Long Walk of the Navajo, the Lincoln County War, the rise and fall of outlaws such as Billy the Kid and Black Jack Ketchum and the invasion of Columbus, New Mexico, by Pancho Villa. All of these occurrences are a few facets of history that helped to form New Mexico into what it is today but also were held against it in its bid to gain the brass ring of statehood.

Revival

New Mexico, with its large Hispanic and Native American populations, was considered to be "too foreign in language, culture and religion" to become a state. The Union was concerned about whether, because of New Mexico's long occupation by Spain and Mexico, the people would or could be loyal to the United States. Unfortunately, corruption by politicians and businessmen in New Mexico's government, called the Santa Fe Ring, would also play a heavy hand in the continual denial of statehood by Congress.

By 1868, the territory saw the arrival of Italian Jesuit priests who brought with them Old World winemaking skills. The Jesuit Order was expelled from Italy by Giuseppe Garibaldi, the great unifier, for backing the king of Naples and his noblemen. This proved to be an advantage for New Mexico when the first archbishop of Santa Fe, Jean-Baptiste Lamy, requested that several of the Spanish-speaking priests be sent to work at San Felipe in Albuquerque.

According to written accounts, French-born Bishop Lamy was not a fan of the "mud city" Spanish architecture of Santa Fe, which utilized adobe as its major building material, nor was he in favor of the artistic efforts of the parishioners in the form of religious Santos, retablos and folk art. In Lamy's opinion, these items lacked the sense of sophistication of the Gothic architecture and art masterpieces Bishop Lamy was accustomed to in his homeland.

Gardening was a great love of Bishop Lamy, who established a small yet prosperous vineyard next to his beloved St. Francis Cathedral in Santa Fe.

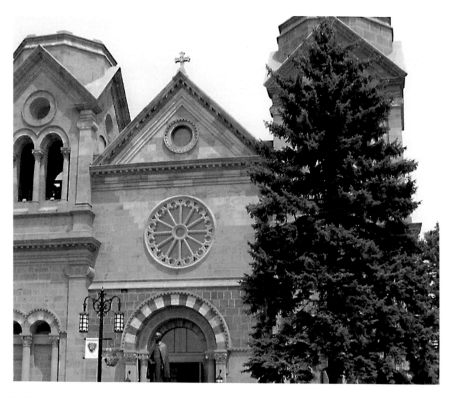

St. Francis Cathedral in Santa Fe, New Mexico, site of Bishop Lamy's garden and vineyard. *Courtesy of the author.*

The original Bishop's Retreat at Bishop's Lodge and Spa in Santa Fe, New Mexico. *Courtesy of the author's collection.*

Today, unfortunately, most of his garden is now a parking lot, but on the grounds of his personal home north of the Plaza in Santa Fe, remnants of his vineyards still exist and flourish under the care of the groundskeepers at the resort of Bishop's Lodge. It has been long thought that Bishop Lamy's favorite wine came from the San Pedro Winery near Senecù. It was written that the first "really fine" orchard in the southwest was in the "Bishop's Garden," planted by Bishop Lamy in Santa Fe. Lamy considered his charge as bishop to be a "holy campaign."

Lamy personally worked hard in his garden as he longed to bring a small piece of France to the savage New Mexican desert. He named his farm *Villa Pintoresca*, which means "picturesque villa." New Mexico was a culture shock to the French bishop, who viewed the citizens of New Mexico to be generally uneducated and corrupt by European standards.

Father Jean Baptiste Rallière, a graduate of the French seminary of Mont-Ferrand, arrived in Santa Fe on November 10, 1856, to be in the

service of Bishop Lamy. Father Rallière was one of six desperately needed priests to arrive to service the entire territory, which had previously been serviced by only fifteen. Two years later, Rallière drew the lot of serving the village of Old Tomé at the tender age of twenty-six. It was in Tomé where the industrious young priest planted wine grapes and orchards on his private landholdings.

According to Ramon Torres, historian for the Immaculate Conception Catholic Church (the church Rallière established) the priest "paid more taxes than anyone else in the county because of his wine." Having his own winepress, Rallière was never without his vino as he traveled his parish and used his wine to his advantage to become "quite an entrepreneur." He employed a *mayordomo*, or land manager, to oversee his property, which he used to educate the locals in agriculture and irrigation.

Rallière was said to have seen the humor in any situation and had a saying for every occurrence of daily life; through his leadership, he made labor sweet, inspired the desire for heavenly joy and glory and earned the nickname *El Patron Eterno*, "the durable father." By 1906, he had 2,100 vines, made twelve vats of wine and sold seven vats to continue his winemaking.

Territorial governor Robert B. Mitchell also encouraged New Mexicans to cultivate grapes. Governor Mitchell, a native of Ohio, was nominated for his position on January 15, 1866, the day he mustered out of the United States Army. Although it is said Mitchell did not appear to take his appointment seriously, his requests led to a new resurgence of vineyards in 1868.

WINE BOOM

By the early 1870s, the Jesuits had firmly established themselves as major wine and brandy makers in the New Mexico Territory wine industry, producing around eighty barrels of wine annually, which was enough to supply the local missions and churches while still having a small amount to sell.

The Order of the Christian Brothers, brought to New Mexico by Bishop Lamy, established a boys' school in Bernalillo, which it named LaSalle Ranch. In order to supplement the everyday operations of the large school, the brothers planted thousands of grape cuttings around their church, Our Lady of Sorrows, and the school. This eventually led to the opening of the La France Winery, which sold wine produced by French winemaker Louis

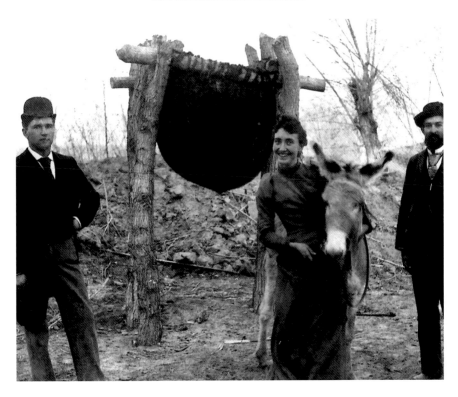

Hide vat used for stomping and storing grapes. *Courtesy of New Mexico State University Library, Archives and Special Collection.*

Gros Sr. Gros produced a staggering ten thousand gallons of wine a year for the order. Gros stayed with the winery until the 1920s, when he went on to start his own vineyard.

The 1870s also saw a rise in wine production in the Tularosa Basin. Native wine, called *cerque*, was made from the grapes grown in the region. This wine was primarily of a crude variety, generally quite sour. The reason for the taste may stem from the process in which it was rendered.

Henry Street recounts a 1932 newspaper article from the *Alamogordo News* that explained the 1870 process. Large hide vats, called *tinas*, were suspended by wooden poles and used by barefooted men in the vineyards to stomp the grapes. These vats were large enough to cause the men to be pulled down into the grapes to knee level as they crushed the fruit to a pulpy mass. Once this process was complete, the grapes were allowed to hot ferment in the hides.

After ten days, the "pummies" (grape skins) were skimmed off the surface. The fermented juice was then dipped into another similar vat

without disturbing the sediment that collected at the bottom, and cool fermentation was allowed to complete. The wine was then placed in small barrels. This process was regarded as finalized thirty days from the second draining.

The article stated:

> *Some wines produced were a well-flavored stimulating beverage, while others made a vinegar-like product that intoxicated and sickened with a nauseating flavor. The most palatable was of course in great demand and brought a better price, but the inferior stuff was still consumed at a profit to the producers.*

It was through the efforts of French vintner Joseph Tondre that a more refined winemaking process was adopted. Tondre was a prominent citizen of Los Lunas, a community south of Albuquerque. He cultivated a thirty-thousand-vine vineyard on his land south of Isleta Pueblo. His success prompted others to attempt the venture. Thirteen wineries opened up along the Rio Grande Valley trying to mimic Tondre's achievement.

Using flat baskets called *chiquihuites* mainly for the harvest, the pueblo residents were hired by Tondre at a wage of fifty cents per day, the going rate, to harvest and tend vineyards and ultimately make the wine from the grapes. About twenty-four chiquihuites equaled one barrel of wine after processing.

Henry Street tells that Tondre would produce eight thousand gallons of wine in the good years, which he brought to the anxious recipients by the wagonload. Since bottles were a rare commodity in the rural sections of the New Mexico Territory, a ladle or dipper was used to disperse wine from the barrels to the waiting customer's containers.

Life was changed forever in the Rio Grande Valley with the arrival of the railroad in 1879. The Socorro newspaper wrote, "The black, fiery-looking smoke-snorting demon-like monster came dashing down the valley of the Rio Grande. It was the first arrival of the railroad in Socorro, yesterday, August 12."

With this modern marvel, the New Mexico Territory was connected with the rest of the United States, and economic commerce had endless possibilities.

In the 1880s, the annual production of wine rose significantly from a mere 16,000 gallons to an astounding 908,000 gallons, thereby launching New Mexico as the leading exporter of wine in the United States. According to the 1880 census, New Mexico had 3,150 acres of farmland in grapevines at this time—nearly double that of New York State.

With the arrival of the railroad, the small town of Lemitar, north of Socorro, along with other communities along the Rio Grande saw a boom in their ability to obtain supplies and quickly ship produce to consumers. This created an unexpected market in Lemitar—namely grapes. By 1890, Lemitar had become one of the largest vineyards in New Mexico with over 100,000 grapevines producing grapes for local and distant wineries. Eventually destroyed by massive floods, few remnants of the historic vineyards can be seen in Lemitar and Polvadera today.

Bruce Ashcroft writes:

> *Winemaking in Socorro predated the territorial period. By 1880 and the start of the boom, vintners made thousands of barrels of wine which sold wholesale for one dollar per gallon. (A barrel held forty-two gallons of wine.) The Mission grape was the most popular, but Muscatels were also harvested.*

William H. Byerts had the largest operation in Socorro, though he wrote modestly in 1911 that he had "a small orchard of 50,000 trees and grapevines." It has been estimated that up to 100,000 trees crowded Byerts's Evergreen Ranch. Byerts also commented on the flavor and quality of his fruit, characteristics that are preserved in the memories of Socorro's oldest residents. Byerts's orchard was located at the base of Socorro Peak, where he tapped into the springs.

The 1899 *Socorro Chieftain* article stated:

> *Abraham Coon grew peaches, prunes, apples and grapes on a fifty-acre farm southeast of town (Socorro). In 1899 he opened a distillery in Socorro to make brandies from his fruits. Flamboyant Giovanni Biavaschi, born in Italy, also ran a distillery in town and was a prominent vintner. In addition, the Hammel Brewery and Ice Plant remained an important business. The brewery also acted as a winery, using Byerts' grapes as stock.*

Corrales, a small community in the suburbs of Albuquerque, stamped its mark on New Mexico's wine industry in the late 1870s with the arrival of European farmers from Italy and France. Among these were the Alary, Imberts, Leplats and Lermusiaux families.

The community welcomed the Lermusiaux family, who moved to the area in 1882 from Noeux-les-Mines, a mining community in northern France. David Lermusiaux was in the wine-growing business from 1885 to 1890 with legendary vintners Victor and Albert Mallet and Louis Gros.

Adolphe Didier, born in Gap, France, to winemaker father Jean, came to Albuquerque in 1885 and then moved to Santa Fe and finally to Belen, New Mexico, to engage in the manufacture of wines. He subsequently became business partners with the Belen Mercantile Company. After eventually withdrawing from that partnership in 1910, Didier manufactured his own wines and became a prosperous merchant in his own right.

The Mission grape was to play another large role in the development of a New Mexico wine region during this time frame. Louis Alary, from Bordeaux, France, planted the grape on his newly purchased land in Corrales in 1880, with much of his Mission vine stock having been shipped to the New Mexico Territory from California. By 1900, the Alary Wine Ranch was the largest in the region, proudly producing wine and brandy in Corrales for over fifty years and specializing in the Black Malvoisie and Malbec grape varieties.

Swiss and Italian settlers, who called Eddy County in the southeastern corner of New Mexico home, had extremely good luck in producing the Malaga grape variety in the region. In fact, the tiny hamlet of Malaga, New Mexico, southeast of Carlsbad, derived its name from this grape. The sandy soil along the Pecos River, the other river that bisects the state, also provides the perfect nutrients for successful grape growth. The remoteness of southeastern New Mexico and lack of the railroad, however, led to the demise of the flourishing grape industry, for without a cost-effective means of getting the fruit to market, the crop was too expensive to produce.

With the arrival of the railroad in 1879–80, New Mexico was finally connected not only with those in the territory but also with the rest of the United States and could import and export its crops to markets previously unattainable. By 1890, nine thousand miles of track had been laid in order to connect the territory of New Mexico with Los Angeles and Chicago, becoming one of the longest railway structures in the world.

In 1883, 100,000 grapevines were planted at Polvadera, a community north of the original site of the first plantings (Socorro). A ditch company was organized, and at the cost of $32,000, three thousand more acres of prime land were brought into grape production.

L&H Huning and Goebels of Albuquerque advertised the availability of forty thousand gallons of wine for purchase in its store in 1884. Franz Huning, a German immigrant and successful merchant, was integral to the arrival of the railroad to Albuquerque, thus opening up the small, newly blossoming community to commerce and leading to that town's steady growth.

Albuquerque's first residential development was named after Huning who built his famous fourteen-room mansion, called Castle Huning or Huning

Castle, square on the line that separated old and new Albuquerque. Built from memory of the style of castles Huning had seen as a child on the Rhine, the home stood proudly in Huning Heights. The unique landmark, a sod brick structure sheathed in wood that was carved to look like brick, was eventually razed in 1955.

As of 1885, the production of the Jesuit winery in Albuquerque rose to 18,400 gallons, which was more than half of the Bernalillo County total numbers. According to the record, the Jesuits shipped wine across the country to California, Kentucky and New York.

By 1890, Albuquerque's Old Town district had become the winemaking capital of New Mexico, boasting ten wineries.

The push to the area of European settlers of Italian and French descent extended the rapid growth of vineyards to the south, therefore improving the quality of wines with the planting of Muscat of Alexandria, Black Hamburg and Mission grapes deeper into the Rio Grande Valley.

The harvest of grapes for sacramental wine inspired the poetic verses of Brandon Banner, which were published in the *Santa Fe New Mexican* in February 1892:

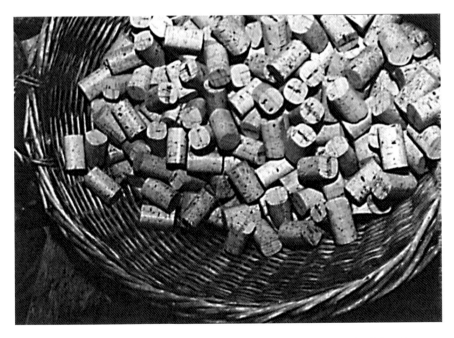

A basket of vintage wine corks used by early vintners illustrates the growth of the wine industry. *Courtesy of the author.*

On the first day of October,
Only in the shining sun,
Only in the dew of morning,
Clusters lifted one by one;
Thus begins the solemn vintage,
Vintage with the Cross for sign
Vino Santo; Holy Wine!

The Trans-Mississippi Exposition of 1898, held in Omaha, Nebraska, showcased New Mexico's resources, including over two hundred examples of turquoise and Mission grapes. The *Santa Fe New Mexican* reported that New Mexico grapes and wine were to be given away at the exposition to highlight the agricultural possibilities west of the Mississippi River. These methods were considered a huge success as many farmers ventured farther west.

The early 1900s saw a dramatic decline in wine production caused by the saturation of the wine market by California wineries that promoted their wines and brandies nationwide. The ultimate high of almost 1 million gallons of wine a year fell to 296,000 gallons in 1890; 34,208 in 1900; and, finally, a low of 1,684 in 1910.

Legislated into Morality

1917 to 1933

No other word struck more fear into the hearts of vintners and bar owners in America, including those in the state of New Mexico, than Prohibition.

New Mexico had been touched by many temperance movements over the early development of the territory. Notables of the movement, such as Frances E. Willard, Marie C. Brehm and the famous Carrie A. Nation, made stops in Albuquerque and Santa Fe in their travels around the country condemning alcohol in any form as the "scourge of the nation." The Woman's Christian Temperance Union, which was established in 1874, and the Anti-Saloon League, founded in 1873, were gaining strength in New Mexico, especially in Albuquerque.

EXPERIMENT IN SOBRIETY

One small community in southeastern New Mexico—Eddy, soon to become Carlsbad—imposed alcohol restrictions on the new residents in 1889 by adding a clause to all real estate contracts that stated no alcohol could be manufactured or sold on any of the land bought within the city limits. Failure to respect this clause resulted in the return of the land to the original seller, Charles B. Eddy, a teetotaler.

The last remnants of Phenix, one of the rowdiest towns in southeastern New Mexico from 1892 to 1895. *Courtesy of the Southeastern New Mexico Historical Society.*

Pharmacists were allowed to prescribe varieties of alcoholic beverages such as whiskey and wine for medicinal purposes only. With residents allowed to write their own prescriptions, the liquid medicine went out the front door faster than it was delivered in oak barrels to the back door. City fathers eventually began to take note of this occurrence and started prosecuting the druggists for supplying too much medicine.

To bypass this rule, prominent community members purchased land about two miles away from the center of Eddy. Here they built a small hamlet with high hopes and named it Phenix. In the beginning, Phenix aspired to be a cultural center of theaters, restaurants and opera houses that allowed alcohol, but as time progressed, outlaws, prostitutes and other seedier members of society discovered the town, turning it into one of the wildest towns in the West.

Phenix would cause its own demise in 1895, when the constant complaints from its sister town finally drove the derelicts out of the New Mexico Territory to the friendly pastures of Globe in the Arizona Territory. By 1898, laws had changed in what was now Carlsbad after the departure of the founding father to Alamogordo, and alcohol had made its way into the heart of the town.

Prohibition in New Mexico had unofficially begun in one of the territory's newest communities.

World War I war efforts were a huge inspiration for the movement. An editorial in the *Santa Fe New Mexican* declared, "If we are to win this war we cannot do it if we are 'pickled.' We should vote 'dry' for our country's sake." The use of grains for the production of alcohol was thought to be undermining the war efforts. It was also during World War I, due to a shortage of men to work the vineyards, that Mexican workers were recruited for the first time in 1917. They have continued to be the backbone of the New Mexico wine industry since then.

It is best to point out that hypocrisy was alive and well in New Mexico as well. Soon-to-be-senator Bronson Cutting, owner of the *Santa Fe New Mexican* and a strong voice openly supportive of the temperance movement, was said to own "perhaps the finest wine cellar in the Southwest," all the while waging war on the lax enforcement of Prohibition laws, according to Oliver LaFarge in his book *Santa Fe: The Autobiography of a Southwestern Town*.

By 1917, New Mexico had approved statewide prohibition by a vote of three to one. Rio Arriba and Taos Counties were the only holdouts. As with the national movement, it was the hope of the state to reduce crime and alcoholism and, in turn, increase the health of its citizens. A noble sentiment, but as with the national ban on alcohol, the people of New Mexico did not take well to the idea, and the incidences of alcohol-related violence and crime in the state actually increased.

Prohibition is the major reason United States citizens have to pay federal income tax—eliminating one-third of the nation's federal receipts from excise taxes on alcohol by banning alcohol, the government had to make up these figures somewhere. Enter mandatory federal income taxes.

During New Mexico's struggles to become a state, corrupt actions were aloft in the attempts to keep New Mexico a territory because they did not include Prohibition in the state constitution. In a Catch-22 situation, supporters of the temperance movement were asked to vote against Prohibition in order for the New Mexico Territory to gain statehood. A January 4, 1911 editorial in the *Albuquerque Journal*, entitled "Fighting Prohibition," illustrates the conflict and confusion:

> *A part of the temperance forces in New Mexico is now engaged in a remarkable fight against prohibition. Because the constitution does not contain prohibition, they would reject statehood; go back to territorialism, where the only possible means of regulating the liquor traffic is high license, or local option or legislative prohibition. Immediate prohibition of no prohibition is their attitude. If you, Mr. Prohibitionist, fight*

statehood, you are giving aid and comfort to the enemy. There is no middle ground.

The constitution was ratified on January 11, 1911, with only one mention of prohibition:

Sec. 13. Sacramental wines.
The use of wines solely for sacramental purposes under church authority at any place within the state shall never be prohibited.

KING ALCOHOL GIVES LAST GASP

New Mexico would obtain statehood less than one year later on January 6, 1912. It became the twenty-sixth dry state on October 1, 1918; the forty-first state to ratify the Eighteenth Amendment on January 20, 1919; and the thirtieth state to vote for the repeal of the same amendment on November 2, 1933.

With human nature including the desire to fight being told what to do, people sought alternatives to purchasing alcohol by manufacturing it for themselves and others. Many times, these methods became a family affair. Popular verses were written in jest, or was it defiance?

Mother makes brandy from cherries
Pop distills whiskey and gin
Sister sells wine from the grapes of our vine—
Good grief how the money rolls in.

Moonshine stills popped up everywhere in the rural areas of New Mexico. Barns, toolsheds, basements and even the many caves that are scattered across the state became the typical settings for operations. It was later rumored during the height of Prohibition that a moonshine still was located in the Carlsbad Caverns, although there has not been evidence found to prove, or disprove, this theory.

The initial hopes of the temperance organizations were to reduce crime, increase health and raise morality by the cessation of alcohol, but in reality, Prohibition had the exact opposite effect. It is said that some towns were so convinced alcohol was the root of all their troubles crime-wise that they sold

their jails when Prohibition took hold. Unfortunately, they would need them soon enough.

Controversy arose as the temperance movement came face-to-face with many contradictions to its beliefs. Dr. Benjamin Rush was one of the movement's largest inspirations, but he actually taught moderation not abstinence. The movement preached that drinking alcohol was a sin, yet it was faced with a fact that was difficult to explain away: Jesus Christ drank wine, a controversy that persists even today.

The insistence was that it was actually grape juice rather than wine of which Jesus partook, but even the Bible extolled the uses of wine, with the drink mentioned over two hundred times in the King James edition. The Bible verse "Use a little wine for thy stomach's sake" (1 Timothy 5:23) caused the movement much distress as it was teaching the citizens of the United States that alcohol was a poison and drinking it was a sin. The verse was quickly interpreted by the group as a literal instruction for people to rub alcohol on their stomachs.

In fact, in the entire Old Testament of the Bible, the Book of Jonah is the only book that makes no mention of wine or the vines on which the grapes are grown. The drys pushed to prove that biblical phrases in which wine was mentioned were only referring to unfermented grape juice. They even went as far as to attempt to eliminate any mention of wine from school textbooks—including the Greek classics.

Temperance activists actually hired a scholar to rewrite the Bible by removing all passages referring to alcohol during Prohibition. What is temperance? To many, the answer is: the proper control of appetite—no matter the vise.

By 1919, there was only a small volume of medicinal-use wine allowed to be produced, but grape growing was still allowed, and the tradition continued in private vineyards and old commercial fields. Defiance to the law occurred in family homes around the state.

Products such as "Vine-Glo," a brick of compressed grapes packaged with yeast pills, appeared on the market to relieve the consumer of his wine withdrawal. Although it was a seemingly perfectly innocent product, the "wine brick" label carried a stern warning: "Warning: Do not place this brick in a one-gallon crock, add sugar and water, cover, and let stand for seven days or else an illegal alcoholic beverage will result."

Fruit Industries, owned by Paul Garrett, was sued by the Justice Department for blatantly marketing a product that was clearly an intoxicating beverage. Garrett fought this effort by hiring former assistant

attorney Mabel Willebrandt, who had enforced Prohibition until 1929. She was now making a living defending a company that was in direct violation of the Volstead Act, an act she had once sternly upheld.

The wine industry was caught in a particularly difficult position in states such as New Mexico, California, New York and Texas, where sacramental wine was used on a daily basis for religious reasons. Under the Volstead Act, wine used for sacramental purposes was given leeway, almost a reprieve. Although the act limited the amount of wine that could be made both at home and at the wineries and stated that wine could be sold only through warehouses under close government observation, the demand for wine needed for religious purposes increased by 800,000 gallons in a two-year period. Consumption of wine rose by nearly 100 percent. Priests and rabbis became some of the most popular citizens of any town.

Prohibition created a boom for one industry: the cruise industry. It was legal to drink alcohol on cruise ships, so "booze cruises" became quite popular even though the ships generally sailed only in circles.

Nationwide, wineries were allowed to liquidate their stocks for the first three months of Prohibition to private buyers. These vintages were greatly prized and were sold at huge prices as a result.

Wineries in New Mexico that did not produce sacramental wine were forced to plow under their vines and plant fruit orchards or other crops in their place. Prohibition made wine less elegant and more utilitarian, and therefore fewer vineyards were planted. It was a vicious circle, which continued for many years even after the repeal of Prohibition and caused great damage to the wine industry as a whole.

Despite the circumstances, New Mexico wine remained a good seller, demanding a four-dollar-per-gallon price tag; the transactions were just forced to go underground. According to reports by the New Mexico State Department of Agriculture, the number of grapevines actually doubled across the state between the years 1920 and 1930.

One winery allowed to remain open for the purposes of producing sacramental wine was the Christian Brothers Winery in Bernalillo, New Mexico, utilizing the skills of professional French winemaker Louis Gros Sr. Through the foresight of Giovanni Giorgio Rinaldi, a Tuscan winemaker who came to Bernalillo in 1918 to farm vineyards and orchards until his death in 1932, the winery recruited help from New Mexico A&M College, now New Mexico State University in Las Cruces, and formed a partnership with the college. Grape production included experimental varieties, which resulted in the development of the Zinfandel grape.

Being a progressive farmer, Rinaldi experimented with different types of grapes and grape-growing styles while striving to improve the grape strain. The Christian Brothers sold the LaSalle Ranch and closed the winery in 1948.

SURVIVAL

Survival was the main theme throughout New Mexico for those involved in the wine industry or even small struggling farmers—a sentiment echoed by Corrales resident Roberta Targhetta during an interview for the local Corrales newspaper, the *Observer*, in August 1986:

> *Before Prohibition came, we used to have a still and made the best grape brandy. When Prohibition struck, we had two choices: Sell the farm, or become bootleggers. My husband served some time because of it, but I'm proud because we did what we had to do to survive.*

According to third-generation New Mexican vintner Robert Jaramillo, of the Jaramillo Vineyards, "My grandfather was known to have produced one thousand gallons of wine annually during Prohibition." This statement was probably echoed in many of the households along the Rio Grande Valley that took great risks to produce their product.

The rural aspect of New Mexico was an advantage at times, especially during the Prohibition era. News spread fast in small communities, and "big city customs agents" were highly recognizable to the locals. By the time these agents stepped off the train in Albuquerque, stills were being hidden in haystacks, false-bottomed vehicles and root cellars. The only alcohol present at the private homes by the time the agents made their rounds was a reportedly undrinkable version of homemade wine or brandy, which was gladly surrendered.

Many stories were handed down through the proverbial grapevine about a nondescript wagon that would travel the back roads and alleys with barrels of wine onboard in the dead of night. Those who wished to partake would approach the wagon with buckets, bottles or jugs to be filled by the driver with a ladle. The means were crude but completely functional.

Federal law provided a clause that allowed the homeowner the ability to have two hundred gallons of wine per year in his home through the purchase

In order to fool residents, federal agents would sometimes wear shoes with soles that resembled the tracks of cattle to cover their own. *Courtesy of the author's collection.*

of a permit, although these permits were reported to be nearly impossible to obtain. Unfortunately for New Mexico homeowners, a provision in the state constitution made these permits illegal within the state boundaries.

Local newspapers carried daily articles of raids performed by the Prohibition officers on small stills and homemade wine makers around New Mexico. Prohibition director D.W. Snyder of Albuquerque and his officers had their hands full with the enforcement of the law.

Prohibition was a time of hardship and confusion for all.

BOOTLEGGING ABOUNDS

Howard S. Beacham, federal Prohibition agent of Otero County, was recognized as "one of the best officers on the Prohibition Force" by the *Roswell Daily Record* in 1930. During his ten-year career, he was credited

Juanita McDaniels, aviatrix and federal Prohibition agent, shown with her automobile and the airplane she used to stop bootleggers. *Courtesy of New Mexico State University Library, Archives and Special Collections.*

with the arrests of many bootleggers in his five county jurisdictions. Chaves, Otero, Eddy, Lea and Lincoln Counties were not only some of the largest counties of the state but also had many bootlegging rings working in them.

Working along with Mr. Beacham was a young woman, only twenty-two at the time, named Juanita McDaniels, an accomplished aviatrix and undercover customs agent. Since Juanita's appearance was so youthful, she could easily infiltrate high school settings to obtain information about the various still locations in the state. Juanita was also credited with the apprehension of an airplane used for bootlegging by shooting it out of the sky.

In an article courtesy of the Tularosa Historical Society, Juanita's praises were sung:

> *Juanita McDaniels Burns took a prominent part in the capture of a rum-running airplane near this city* [Roswell] *several years ago. The ship was captured by Howard Beacham, federal prohibition agent and deputy sheriff J.B. Coats, upon tips received from Miss Burns at El Paso, she being under the employ of the customs service at the time.*

Juanita, who would later be known as Juanita Burns, went on to set a new women's altitude record in an open-cockpit, high-winged monoplane on December 28, 1931. Breaking the previous record of 21,598 feet set by Ruth Alexander, Juanita's third half-hour attempt netted her a reading of 28,000 feet. Her lofty dreams of a solo round-the-world flight would not come to fruition due to lack of funding at the beginning of the "Dirty Thirties."

It was Howard Beacham who helped apprehend the infamous Machine Gun Kelly, who was in New Mexico under the alias Franklin Turner, allegedly selling alcohol in the Indian reservations. Kelly spent three months in the New Mexico State Penitentiary, an experience he was reported to say was one he never wanted to repeat.

It is written that Will Shuster, a famous New Mexico artist and the creator of Old Man Gloom, otherwise known as Zozobra, was a bootlegger in Santa Fe.

Speakeasies, wine parlors and backroom bars sprang up all over Santa Fe and Albuquerque and kept law enforcement busy in the pursuit. The speakeasy, sometimes called blind pigs or clip joints, changed the way New Mexicans drank. Gone were the leisurely meals that included a drink; instead, alcohol was consumed less often but in larger quantities. The speakeasy was, plain and simple, a place to get drunk. This was also the first time it was fashionable for women and young adults to drink.

There were an estimated twelve operational stills within a block of the Santa Fe Plaza, which meant most of the illegal bars in Santa Fe were in private houses. Many people were even arrested enjoying a glass of wine in their own homes if observed by law enforcement.

The moonshine that was produced in the rural areas all across the United States, as well as in New Mexico, was a concoction of available chemicals, such as creosote, kerosene and embalming fluid, which often had lethal results. Those stills resembled the methods used today by those who are making the highly illegal and volatile drug methamphetamine.

Growing and shipping grapes was not illegal, but if it could be proved that the shipper knew the intentions of the buyer to be winemaking, then both were charged with conspiracy. It was the French who helped overthrow Prohibition in the United States by pledging a large fund.

Local newspapers report in 1920 that wild cherry wine and blackberry cordial were added to the list of intoxicating liquors. These could be sold by druggists in the amounts of five gallons for persons with permits. Also on the list were elixir of anise, bitter orange, compound of juniper, myrica and lavender.

In December 1922, the *Albuquerque Journal* reported a case of Prohibition violation in Gallup, New Mexico:

A flask of spirits cleverly concealed in the garter of a lady of the "Dirty Thirties." *Courtesy of the Library of Congress.*

Redo Spenovich was arrested Thursday by the direction of the Sheriff of McKinley County. A large number of arrests have been made, but in no instance have the results been as remarkable as in this case. Ten barrels of wine, either fermented, or in the process of fermentation, was [sic] found in the house occupied by Spenovich. This is by far the greatest amount of alcoholic beverages ever captured in McKinley County. Spenovich was given six months in jail by Judge Schauer. He gave as a plea of defense that he was unable to work on account of having Tuberculosis and he was making the wine for his own use because there was little solid food he could eat.

Some of the more creative excuses for winemaking during Prohibition, along with the one used above, included: "The wine made wasn't intoxicating," "[I] found [a] vintage cask of wine in a railcar" and the classic, "The wine made me steal."

It is unfortunate for all involved that the dozen or so wineries that reopened in New Mexico after the repeal of Prohibition along the roadsides at Algodones, Bernalillo, Corrales, Albuquerque, Belen, Sandoval, Doña Ana, Mesilla and Las Cruces were not able to compete with the deluge of wine from California and eventually closed under the pressure. Vines were plowed under, most never to be replanted again, a sad end to a once thriving industry.

By 1977, only three wineries remained in Corrales, Albuquerque and Las Cruces, and some of them were ironically making their wines with California grapes.

Frost, Floods, Hoppers and Drought

The wine industry of New Mexico has not been an easy road to travel. After overcoming the many human-initiated problems, it was Mother Nature who seemed to have taken quite a bit of joy in raising havoc with the New Mexico vintners.

LITTLE ICE AGE

Throughout the years, killing frosts have caused many downswing years for the vineyards in the northern regions of the state. Generally occurring in March or April just as the grapevines are at their most fragile state, the ice stunts, if not completely stops, growth of the vines, forcing the vintners to start from scratch as all crops are lost.

Between the years 1540 and 1860, a period known as the "Little Ice Age" was a worldwide event. The term "ice age" is misleading, but there is evidence through the journals of those traveling with Spanish conquistador Francisco Vázquez de Coronado, who brought the first Spanish army into New Mexico the same year, of abnormally cold temperatures and extremely heavy snowfalls in the northern region that caused great suffering for the explorers.

Fray Benavides noted in 1630 that the winters in New Mexico were "very rigorous" and with "so many snows, frosts and cold" that the rivers and other surface waters would freeze solid.

Cracks in the church bells of the missions were most likely caused by being rung in the cold weather. It was difficult to find a bell that hadn't been cracked in the state of New Mexico.

These conditions were mentioned in the 1795 diaries of Fray Francisco Atanasio Dominguez, who inspected the northernmost missions of New Mexico and reported on the condition of the vineyards: "The fruit of the

David Wickham of Tularosa Vineyards displays only one small pile of vine branches pruned after the big freeze of 2011. *Courtesy of the author.*

grape vines is seldom harvested, because they freeze most years." Growers found the Albuquerque Valley, near Corrales, New Mexico, to have more favorable conditions, so much so that many were able to produce extra wine and reap the profits from selling what they produced.

The bitterly cold winters of the early 1800s saw most residents spending six months of the year inside. The severe cold of 1863–64 caused the Navajo tribe so much distress that it surrendered to the United States Army to find relief for its people. According to the church documents of Our Lady of Sorrows Church of Las Vegas, New Mexico, wine froze in the challis on the altar, meaning it had to be at least twenty degrees in the church at the time.

Many wineries in New Mexico were convinced the Little Ice Age had returned over a century later, on February 2, 2011, when temperatures across the state ranged from a negative sixteen to negative twenty-three degrees below zero. This horrific weather event resulted in many vineyards losing up to 90 percent of their vines while creating a considerable amount of financial strain on the already struggling small wineries.

Dubbed the Ground Hog Day Blizzard by state weather officials, the unprecedented storm resulted in the longest sustained cold spell in twenty-five years. New Mexico was blanketed with snow and ice, leaving fifty thousand residents without heat and gas for a week.

As you travel the state, you can see the vineyards in various degrees of growth and health as they begin their recovery process. The harvest for the 2012 season was promising and gave hope to the vintners that a new era of prosperity was upon them.

HEAD FOR HIGHER GROUND

The Rio Grande, at 1,885.24 miles long, bisects the state of New Mexico and at one time created the border between the United States and Mexico. It is the second-longest river in America, coming in just behind the Mississippi River, which boasts 3,781 miles. The source of life for many in the state, the Rio Grande has provided water for irrigation, food from its waters and a means of navigation for the people who populate its banks.

The Spaniards wrote of the severe flooding of the Rio Grande in their journals:

> *This river is in flood from mid-April to the end of June. The force of the freshets depends upon whether the winter storms have been heavy or light,*

but they never fail, for it always snows more or less. In a very rainy year the flood season lasts a long time and the longer it lasts, the greater damage it does, whether to people or cattle that are drowned, or to farmlands that are swept away, or even to the nearby houses that are carried off.

It was during the flooding of the Rio Grande that occurred on May 28, 1874, when Albuquerque literally became an island. Records reveal that approximately twenty-four square miles of water-filled area stood between Bernalillo and Albuquerque for three months. The river produced an all-time record flow of 100,000 cubic feet of water per second during this particular flood.

It is unfortunate that the Rio Grande is also fickle and has a tendency to flow a different course from time to time as the result of flooding. By 1880, the Rio Grande had shifted its course to the west several times. Because of this flooding, supply trains were often delayed, bringing more hardship to the valley.

The need for irrigated land grew from about 20,000 acres in the beginning of the 1800s to an astounding 125,000 acres by 1880 because of the population growth. This increase caused a serious deterioration of the river, resulting in the depletion of downstream river flows, the rise of sedimentation, unstable river flow and waterlogged lands. The effect was root rot in the grapevines planted along the Rio Grande.

During a massive flood in 1884, which was witnessed by New Mexico archaeologist Adolph Bandelier, Santa Domingo Pueblo saw extensive damage. According to historian Marc Simmons, Bandelier was later quoted as saying that such flooding must have played a major role in "burrowing new channels, obliterating Indian pueblos and changing the location of farm plots."

In springtime, thawing snowpacks and intense rains were a contributing factor to the river overflowing its banks on a regular basis. Although a time of renewal, spring brought fear to the hearts of the first residents along the river, for they knew they would most likely have to flee their homes for higher ground and return only after they had dried out—an unwelcome ritual.

Major flooding, caused by runoff from the Rio Grande in 1904, caused the destruction of all field crops, vineyards and orchards in the Rio Grande Valley. Water stood in the vineyards for several weeks, which inhibited the farmers from taking precautions against the freeze damage that would occur in the winter.

Family journals of the Alary Wine Ranch located in Corrales indicate that the flood occurred on the second day of the harvest. Two wagonloads

of grapes were ready to leave the farm at 4:00 a.m. on their way to the winery in Albuquerque, but at 2:00 a.m., the mighty Rio Grande flooded its banks and the entire valley. Tragically, the Alary home and vineyards were destroyed. The Alary Wine Ranch did not have a grape harvest in 1905.

According to records, the Middle Rio Grande Valley is one of the oldest populated regions in the United States and therefore one of the most utilized agricultural areas in the state. The year 1926 brought the first major flood that impacted the vineyards from Bernalillo to El Paso.

Several dams were built along the Rio Grande to prevent the massive flooding, but it wasn't until Elephant Butte Dam was built by Truth or Consequences, New Mexico, in 1916 that the destruction was finally curbed. At the time of the dam's completion, it was the second-largest irrigation dam ever built (Aswan Dam in Egypt being the largest).

At 301 feet high and 1,674 feet wide, Elephant Butte Dam cut a mighty figure in the desert landscape. At the cost of $8 million, the project of the United States government allowed the reclamation of over 200,000 acres of prime farmland along the Rio Grande Valley. The massive Elephant Butte

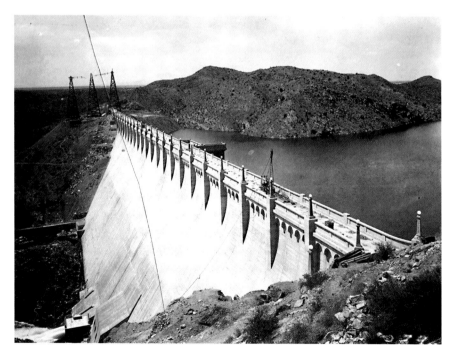

The construction of Elephant Butte Dam brought stability to the Rio Grande Valley. *Courtesy of the Library of Congress.*

Dam was constructed with 618,785 cubic yards of concrete. The dam holds 2,210,298 gallons of water and generates power and electricity for central New Mexico.

The unusual name for the dam came from the volcanic core rock formation that was close to the build site and resembled the shape of an elephant lying down. The formation is now an island in the lake. The original name for the structure was Engle Dam, after the Santa Fe Railroad stop that sprang to life during the dam's construction. Engle, now a ghost town, advertised itself as "the best town in New Mexico by a dam site." Today, the Engle area, which includes wonderful views of the Jornada del Muerto, is home to the Armendariz Ranch, owned by television mogul Ted Turner, and several vineyards for the Gruet and St. Clair Wineries.

HOPPERS

Throughout history, the lowly grasshopper has been credited with massive destruction. Clearly one of the worst forms of pestilence to annoy the agriculturalist, the grasshopper has long been the subject of Navajo folklore, which explains it as a disguise for ghosts, the cause of nosebleeds in children and even as a retribution tool for witches, according to New Mexico State University papers. There was no love lost between the native peoples, or the Anglo-American farmer, and the grasshopper.

A news article featured in the *Albuquerque Journal* in July 1922 saw some humor in the infestation problem.

> GRASSHOPPERS GNAW GRAPES OFF VINES AND GO ON A SOUSE: *Weird stories are reaching the city of the sagacity shown by grasshoppers in their quest for food in the Rio Grande Valley. In one section where vineyards flourish, the hoppers jump into [sic] the vines, gnaw off a bunch of grapes at the stem and then call in their children and mothers-in-law to enjoy the feast. When the grapes begin to ferment before they are eaten the hoppers are said to show signs of intoxication and go hopping about "looking for a fight." The hoppers have attacked the watermelons along the river and are said to have done great damage to the crop. Turkey growers in the valley say the gobblers are getting fat on grasshoppers, so that at Thanksgiving time the market will have some unusually fine birds on display.*

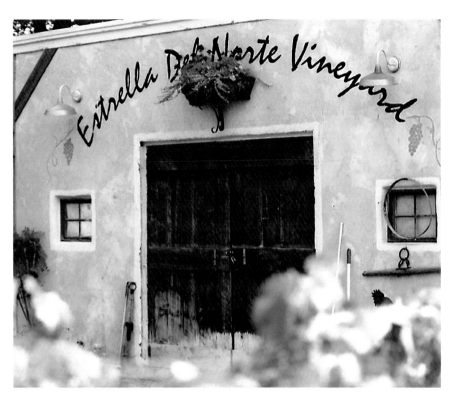

Above: Color and art abound at Estrella Del Norte Winery. *Courtesy of the author.*

Left: It's easy to see why the impressive Barranca Blancas Mountain across the street from Vivác Winery is the inspiration for its label. *Courtesy of the author.*

Above: The tasting room of Corrales Winery boasts spectacular views of the Sandia Mountains. *Courtesy of the author.*

Left: Henry and Mary Street, the charming owners of the Ponderosa Valley Vineyards and Winery. *Courtesy of the author.*

Jeremiah Baumgartel, winemaker for Ponderosa Winery, shares the Streets' passion for the wine industry. *Courtesy of the author.*

Sarah Eischeid, tasting room manager of Rio Grande Vineyard and Winery, shares her great love of wine with her patrons. *Courtesy of the author.*

Co-owner James Dann, along with his brother Robert, has been producing great wines at Dos Viejos Winery since 2009. *Courtesy of the author.*

Above: A collection of award-winning wines of the Heart of the Desert Winery. *Courtesy of the author.*

Right: The Cellar Uncorked winery in Ruidoso, New Mexico, is proud to house the Noisy Water label. *Courtesy of the author.*

Art and wine go hand in hand. Estrella Del Norte Vineyard is graced with artwork by Jaque Fragua and Watermelon 7. *Courtesy of the author.*

Opposite, top: Wine barrel display greets patrons at the entrance to Estrella Del Norte Winery. *Courtesy of the author.*

Opposite, bottom: Beautiful La Chiripada Winery in Dixon, New Mexico. *Courtesy of the author.*

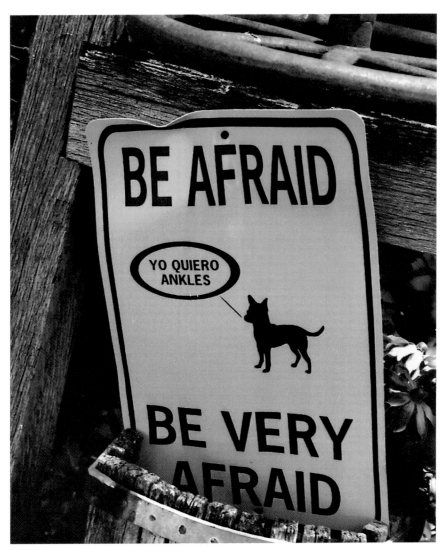

Animals play an integral role at Ponderosa Valley Vineyards & Winery. *Courtesy of the author.*

The face tree keeps watch over the garden at Ponderosa Valley Vineyards & Winery. *Courtesy of the author.*

Front gate display at the Ponderosa Valley Vineyards & Winery. *Courtesy of the author.*

Opposite, top: The trademark red 1951 GMC pickup at Ponderosa Valley Vineyards & Winery. *Courtesy of the author.*

Opposite, bottom: Roses grace the ends of the vineyard rows and tell of the vine health at the Rio Grande Vineyard & Winery. *Courtesy of the author.*

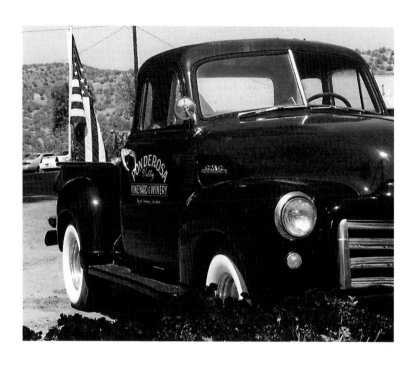

Patio views of the Organ Mountains from the Rio Grande Vineyard & Winery. *Courtesy of the author.*

A cluster of grapes from the Balzano Winery vineyard in Seven Rivers, New Mexico. *Courtesy of the author.*

Vineyard harvest of the Balzano Winery near Carlsbad, New Mexico. *Courtesy of the author.*

Above: Delivery truck and
wine barrel display at St.
Clair Winery & Bistro
in Mesilla, New Mexico.
Courtesy of the author.

Left: Winery grounds of
Casa Rondeña Winery as
seen from the tasting room
window. *Courtesy of author.*

Vintage Wines' colorful sign at the entrance of its wine bar in Mesilla, New Mexico. *Courtesy of the author.*

Heart of the Desert Winery's tasting room, located on the Plaza in the historic village of Mesilla. *Courtesy of the author.*

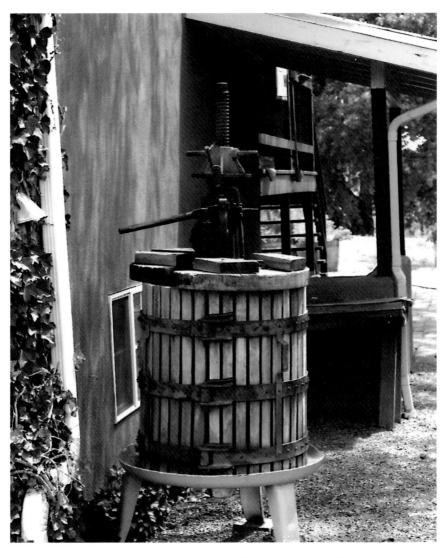

Antique wine press on display at the Ponderosa Valley Vineyards & Winery. *Courtesy of the author.*

The first major infestation in New Mexico occurred in 1927. It was then that the mechanical hopper dozer, a metal scoop-like contraption coated with tar and dragged through the fields, was used to extricate the insects from crops. Even prior to this, Spanish explorers' journal entries tell of troubles with the pests in the sixteenth century, explaining how the insects stripped the crops and, therefore, the livelihoods of the people who depended on them.

One ingenious farmer came up with his own solution: fight the hoppers with themselves. He mixed ground-up grasshoppers with water and used this concoction as a spray for his field. It worked for a time. Swarms of infestations would come to New Mexico in waves. In 1967, reports of massive populations of grasshoppers, eight or more per square yard in an area of five and a half million acres, caused devastation to Torrance and Lincoln Counties.

Damage caused by grasshoppers spanned not only the physical crop but also social and economic realms because the grasshopper decimated crops of the already poor farmers. Prices would rise on produce in the marketplace, creating a vicious cycle. Grape growers in New Mexico constantly combat the grasshopper in their fields today, and some qualify for assistance in the battle from the federal government. Natural forms of pest control have been developed to reduce the use of harsher chemicals such as dichlorodiphenyltrichloroethane, better known as DDT, which had been used since the late 1940s.

The reduction of the grasshoppers' food source, which includes crops and the surrounding weeds, is the key to controlling their population levels. Weed control is essential and is widely practiced by New Mexico farmers because grasshoppers thrive in weeds, which they use for food and shelter. Regular crop dusting is used to keep the pests under control as well.

Drought

New Mexico has some of the most diverse and beautiful landscapes in the country, but it is also subject to intense periods of drought, which lead to dry riverbeds, deep erosion, crop failure, famines and damaging dust storms. It is written that the drought years occur in "swarms" lasting from a couple of years to up to ten years at a time. In the 1500s, history shows that the pueblos

farthest away from the Rio Grande, which had to rely totally on rainfall for crop irrigation, suffered greatly as the toll of the vast drought cycle took hold.

The first famine in recorded New Mexico history occurred between the years 1620 and 1629. It was during this time frame that the Apache were so distressed with their inability to find food that they brought their own children and captured slaves to the Pueblos to trade for food. By the summer of 1659, the Pueblos and Spaniards were forced to eat grass seeds, herbs, green barley, spinach and bran to survive.

The native people, who believed that weather was controlled by gods showing their displeasure with the people by forming a bad climate, were losing faith in the Christian religion they were being taught because of the drought. They believed the new God they were told about should be able to stop the drought. Because of this belief, the native people reverted back to their own rituals in hopes of changing the weather. This lack of trust also played a large role in the Pueblo Revolt of 1680.

One of the most severe droughts of the colonial period occurred between 1772 and 1785. People resorted to eating their shoes, saddles and cowhides—anything to provide protein. It was also during this period that smallpox spread rampantly through the region, killing 5,025 Pueblo Indians.

During the Dust Bowl of the 1930s, the trademark red dirt blown from the fields of New Mexico, Texas and Oklahoma could be found on the decks of ships hundreds of miles off the Atlantic coast. Even the lowly rabbit, which could customarily survive without water for long periods of time, was dying of thirst and starvation.

Drought still plagues New Mexico. In the year 2011, a staggering 79 percent of New Mexico was affected by moderate to severe drought. According to the archives, 1956 was the only year that saw a worse drought season than 2011. During 2011, the beautiful Bandelier National Forest of northern New Mexico received only five inches of rain, which sadly led to the death of millions of acres of yellow pine, cedar and spruce trees. Other trees in the forest became victims to the invasion of beetles, which thrive in drought conditions.

Lightning storms, spawned by the low humidity of the drought in 2011, sparked wildfires in every wine region that came dangerously close to several of the state's wineries. According to reports, most of the grape-growing regions of New Mexico receive between six and fifteen inches of rain annually with support from local irrigation aquifers, but with the drought conditions, they received significantly less.

Resurrection of Viticulture in New Mexico

1977 to Present

Baby Steps

The movement to bring wine back to New Mexico began in the backyards of local hobby growers. It is said much of this wine was undrinkable, but as time advanced, so did the skills of the vintners and the science of winemaking. The wine industry got a significant boost when a government-funded study encouraged local growers to begin planting French-hybrid grapes in 1978, thus allowing small commercial wineries to begin opening their doors to the public once again due to the growing of hardier grapes.

New Mexico has four distinctive winegrowing regions: the Northern, Central, Southwest and Southeast Regions. Each wine produced is a reflection of the region in which it is grown. Each has its own unique taste due to the different growing methods, grapes and soil used by each vintner.

La Viña Winery in La Union, New Mexico, on the border of New Mexico and Texas, bravely opened its doors for business in 1977 and confirmed its place in history as New Mexico's oldest continually run winery. La Chiripada comes in a close second, being the oldest winery in northern New Mexico. Anderson Valley Vineyards started business in 1973 but sadly is no longer in operation.

New Mexico owes gratitude to the United States military and the Atomic Energy Department, for many of the top winemakers of the state were

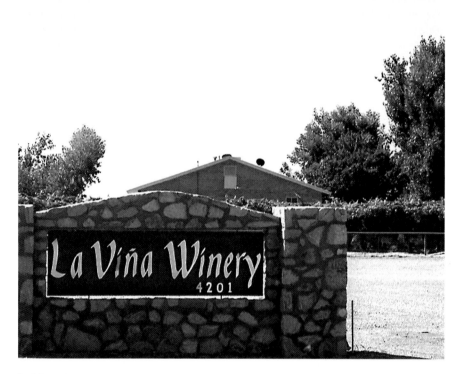

La Viña Winery resurrected the New Mexico wine industry in 1977. *Courtesy of the author.*

once employed in this field. Science and winemaking go hand in hand. The attention to detail that scientists and engineers need to work for an environmental organization, such as Los Alamos National Laboratory or Sandia National Laboratories, translates nicely to the formulas and recipes used by the scientist-turned-vintners in their winemaking endeavors.

Grapes as a crop are economical, taking only one-fourth as much water to produce a viable harvest as the same amount of alfalfa and having the potential to bring in about ten times as much revenue. Water has always been an issue in New Mexico, whether it is way too little or far too much, and a happy medium is rarely reached. Therefore, crops that require less water are highly prized.

The roller coaster ride that is the wine industry in New Mexico continued as commercial grape production waxed and waned. European winemakers, lured by a great climate and cheap land prices, made New Mexico their home and sparked resurgence in wine interest in the early 1980s by taking a chance on a business that has been touched by much turmoil. This trend was to see

Gruet introduced the world to a taste of New Mexico bubbly. *Courtesy of the author.*

a decline by the end of that decade, with only one thousand acres of grapes being grown.

German, Swiss and, of course, French families took an interest in the Truth or Consequences area for winemaking and quickly bought up the land to put New Mexico planting levels back to pre–Civil War levels.

One of these families was the Gruets, currently the third-largest sparkling wine producers in America. Gruet's sparkling wines are credited with finally putting New Mexico on the world wine map. By 2008, Gruet Winery had sold 100,000 cases of wine and distributed its wine to forty-eight states. Its Gruet NV Extra Dry Blanc de Blancs won a silver medal in 2011 in

both the San Diego International Wine Competition and the New World International Wine Competition.

The Gruet family was in the first contingent of French winegrowers who saw the value of the land around Engle, New Mexico, in Sierra County. Initially, to water the proposed twenty-one-thousand-acre project, the Gruet family relied on a pipeline to bring the life-giving irrigation water from the Elephant Butte reservoir to Engle. The *Vinifera* varietals were on their way to resurgence.

Different parts of the state joined in the excitement, as the forty-thousand-gallon-a-year winery La Viña Madre in Dexter, New Mexico, south of Roswell, proved by the quantity of its production. Although the enthusiasm of the six new wineries was encouraging for New Mexico, the industry was still on shaky ground. The unpredictable New Mexico weather continued to be an obstacle, as was as the fact that some of the largest new vineyards were planted in old cotton fields, which eventually led to the death of the vines from cotton root rot.

Without a defined wine market in New Mexico, the competition from California and Europe began to pinch sales from the state, causing the vineyards to dwindle in size and number. Unfortunately, because of overextension, 1993 saw the reduction and closure of some wineries. Other wineries in the state learned from their earlier errors and began planting a disease-resistant rootstock that was better suited to the New Mexican weather patterns and provided for better vine growth.

It was through the Herculean efforts of New Mexico State University's School of Agriculture in Las Cruces that the cultivation of grapes in the state has reached the point it is at today. Pioneer Fabian Garcia developed experimental gardens to advance the knowledge of chiles and grapes. These gardens are a favorite spot in Las Cruces for tours and wedding venues due to their beauty. New Mexico State University is continuing the tradition by offering agricultural classes to develop new strains of these two crops.

A new program offered at New Mexico State University is a winemaking class available to students for credit and to the public as an extension workshop. In this class, students of at least twenty-one years of age gain hands-on experience in making, bottling and labeling Zinfandel and Dolcetto wines. Taught by Bernd Maier, New Mexico State Extension viticulture specialist, and Bill Gorman, professor emeritus of agriculture economics and agriculture business, the class has proved to be a popular elective.

Gordon Steel, owner of the Rio Grande Vineyard and Winery, recruits students from the university to work at his business. Steel's family has had a

long-standing relationship with New Mexico State; his ancestor Sam Steel was even honored with a campus roadway named for him after his tragic death.

The Vine and Wine Society states:

> Today the New Mexico wine industry is expanding rapidly, according to Bernd Maier, Extension Viticulture Specialist in New Mexico State University's Extension Plant Services Department. He reports that production is expanding by 10–15 percent annually. The New Mexico Wine Growers Association website lists more than 50 wineries spread around the state. Economic impact in the state exceeds $60 million.

According to a survey taken by Nasiba Alimova and Jay M. Lillywhite of New Mexico State University in 2004–5, 112 of the 10,000 grape varieties grown around the world are cultivated in New Mexico. Grapes are the most planted fruit on the planet, followed in no certain order by apples, cherries, lemons, oranges and figs.

Land of Enchantment

Bright Future

At the top of the roller coaster at the moment, thanks mainly to the reemergence of the wine festival, the New Mexico wine industry is enjoying a much-deserved boom. New Mexico is host to at least ten wine festivals, with the number still growing. Each year, wine festivals located in every wine region of the state attract forty thousand wine lovers, boosting not only the winery sales but also the economy of their towns. These many wine festivals have opened the eyes of wine lovers from both New Mexico and elsewhere to the unique tastes of the Land of Enchantment.

With the passage of Senate Bill 445, Direct Shipping Legislature, in April 2011, New Mexico can now ship its wine to a majority of other states, but more work needs to be done to include them all. Given additional favorable legislation, New Mexico wines' resurgence will continue.

Unique Wine from a Unique Land

Unique is probably the best word to describe New Mexico as a whole. Unique are the four cultures, consisting of Native American, Hispanic, black and Anglo-Saxon, that make up the fabric of its society. These are represented in the Zia symbol emblazoned on the state flag. Unique is the land itself. In the course of a day trip, a person can travel through mountains, plains and deserts enjoying magnificent vistas without leaving New Mexico's borders.

Unique architectural styles, such as Pueblo, Territorial, Art Deco and Traditional, give the observer a visual feast. Unique and delicious culinary treasures are available, including red and green chiles, the state vegetable and a staple in the New Mexico diet. Although reproduced other places, New Mexican food can never be truly duplicated with the pure flavor of ambiance that comes straight from the rich soils and the loving hands of wonderful cooks.

Most importantly, New Mexico is unique in its completely distinctive wine regions, which bring great pleasure to the palate of the person lucky enough to drink in their varieties of liquid goodness. New Mexico may not be the best-known wine industry yet, but it is certain that once you taste the wines it has to offer, you will never forget the experience and come back for more.

Whether your wine taste is dry or sweet, there is a New Mexican wine to fit the bill. Novelty wines are also big business in the state wineries as new, interesting wine flavors, such as chocolate, pomegranate and, of course, chile, are available on the market.

St. Clair's Winery has developed a niche in the novelty wines market with the introduction of its chile-enhanced wines. The Hatch Green Chile wine was introduced to rave reviews. It's not overtly spicy as one might imagine but drinks smoothly, with a zip in the aftertaste from the green chile.

The newest member of the chile wine family is St. Clair's Chimayó Red Chile Wine, which is a combination of Chimayó red chile powder, called *molido*, and red wine that gives a rich, deep, smoky spice over a dark berry flavor, leaving a peppery warmth in the mouth. Although some may not consider the wine agreeable for sipping, it makes a fabulous meat marinade.

It is with the hard work and dedication of the New Mexico winegrowers that the state is being recognized as a more-than-worthy contender against national and international wine markets. Gruet Winery, for example, was awarded the title of United States Wine Producer of the Year by the International Wine & Spirits Competition in 2010. It is said that New Mexico's wine is a curiosity (mainly by residents of California), but it's certainly a curiosity that needs to

be thoroughly explored and satisfied. In counterpoint, it comes as a surprise to most New Mexicans that the world is not aware of their vast wine prowess, despite the state's being the oldest wine region in the United States, and they are determined to change this perception.

"Gruet Winery is the standard-bearer for New Mexico's growing wine industry," claims W. Blake Gray of *WineReviewOnline*.

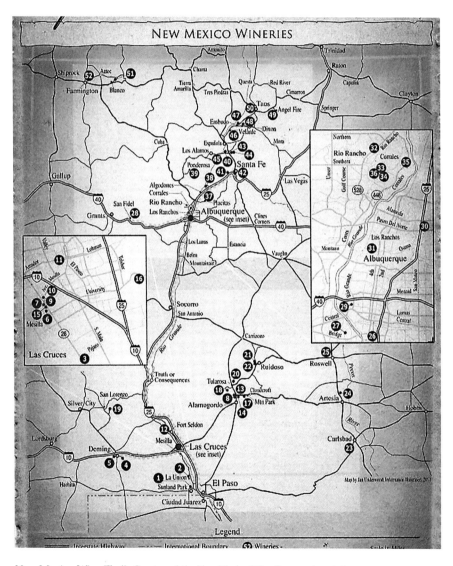

New Mexico Wine Trail. *Courtesy of the New Mexico Wine Growers Association.*

New Mexico's winemaking success can be summed up in one word: terroir. Sun-soaked soils and cool, high desert nights give New Mexico a unique advantage to its neighboring states.

"Vintning in the state of New Mexico has an environmental philosophy of good stewardship of the land and a preservationist's perspective to protect the culture of small-town farming and community"—words wisely stated by author Mike Marino.

Progression of the wine industry is the focus of New Mexico's winegrowers. State wine associations are partnering with local universities to train future generations in the art of viticulture and enology, most recently in the northernmost growing region. According to Michele Padberg of Vivác Winery of Dixon, New Mexico, "We're all looking at increasing the wine industry in New Mexico, and everything we can do to employ locals, to encourage this program to expand, all of that just comes back to our communities."

It is the hope of all the New Mexico vintners that you will take some time to travel in the beautiful state of New Mexico. Take a journey along the wine trail as it follows the length of the state in the Rio Grande Valley, and you will discover all of the wineries that the Land of Enchantment has to offer.

New Mexico will draw you in with its turquoise skies, breathtaking vistas and hidden treasures. Drink in the romance and history of this enchanting state with each taste of its truly extraordinary wines.

Hold up a glass of New Mexico wine to the sun, and you will clearly see the quality of the liquid that captures the awesome beauty and mystery of the Land of Enchantment, with the vibrant colors of its magnificent sunsets reflected in the goblet. As Galileo Gallilei is quoted to have said, "Wine is sunlight held together by water."

Commitment to excellence and the richness of the New Mexican soil coupled with the skill and passion of its winemakers sets New Mexico far above its competitors not only in taste but also in heart. Claim your share of the 920,000 gallons of wine produced by New Mexico each year. New Mexico truly has nothing else to prove to the wine world—its time as a celebrated wine region has arrived!

Enchanted Wine Trail

The New Mexico Wine Growers Association launched a distinctive program in November 2010 to draw attention to the many wonderful wineries scattered throughout the state of New Mexico: the Winery Passport Program.

With fifty-four wineries in the state and counting, forty-six of which are participating, the program is an excellent way to visit and savor the taste of New Mexico wine. The Passport Program allows winery patrons to be rewarded with prizes while drinking their favorite vino. With a purchase of ten dollars at participating wineries, you are eligible to receive a stamp for your passport. Once your first passport is filled with four stamps, simply register at www.nmwine.com and enter the stamp codes. It's that easy—you will receive a gift for every four wineries you visit. The top prize has been a Caribbean cruise in the past, with the promise of bigger and better prizes as the Passport Program grows.

Although each winery offers myriad different wines to choose from, the all-consuming passion of the vintners for their trade is universal. Each has a unique story that he or she is more than eager to relate. It is true to say that the New Mexico wine industry is the perfect blend of many cultures, including American, French, Italian and Spanish, creating the delectable wines that are as remarkable as the state itself. New Mexico's legendary diversity continues with its wine industry

It is the hope of the New Mexico winegrowers to entice you to experience the wonders of the state while enjoying the fruits of their vines with a glass of your new favorite wine.

Follow along on the New Mexico Wine Trail as we explore the four very distinct wine regions of the Land of Enchantment and the equally matchless wines they offer. Although there is definite competition among New Mexico's winemakers as they each vie for the patronage of wine lovers, it is the fact that they act like a big family, evident in their willingness to help one another out in times of strife or by sharing equipment, that warms the heart. It can truly be said that the winemakers and winery owners are some of the most inviting citizens of the state of New Mexico. It is my hope that this book will inspire you to take your own wine journey to discover all the wine New Mexico has to offer. You will not be sorry you did.

Northern Region

The northern region of New Mexico wine country reflects the Northern American Viticultural Area, which includes the topmost one-third of the state.

Black Mesa Winery

In historic Velarde, New Mexico, between Santa Fe and Taos, Black Mesa Winery is nestled between the Sangre de Cristo Mountains and the banks of the Rio Grande of northern New Mexico. The winery is staffed by friendly people, eight equally friendly "mesa kitties" and one confused dog named Boo. Black Mesa Winery offers a selection of over twenty-five wines produced from New Mexico grapes.

Owners Jerry and Lynda Burd purchased the winery in 2000 from Dr. Gerhard and Connie Anderson, who started it in 1992. Black Mesa Winery offers award-winning Cabernet Sauvignon, Sauvignon Blanc, Primitivo, Chardonnay, Malbec, Pinot Grigio, Montepulciano, Riesling, Pinot Noir and Viognier.

Many of the winery's selections are blends originating with the Andersons. With all of these great wines, what more could you want? How about a chocolate wine? The most popular seller at Black Mesa is its exclusive Black Beauty, a chocolate-flavored red dessert wine. Suggested pairings include cheesecake and strawberries, but the perfect pairing has already been done in the bottle—wine and chocolate. Black Mesa describes the wine: "A little sweetness, a little chocolate, a little naughty, could lead to dancing."

Black Mesa Winery, where art and wine go hand in hand. *Courtesy of the author.*

Along the El Camino Real, Black Mesa Winery is firmly set in its namesake, taking full advantage of nature's gifts. The winery evokes the true essence of New Mexico with its Black Mesa Coyote wine. A serious dry red wine, Coyote has stepped forward as a favorite among red wine enthusiasts.

Lynda Burd—co-owner, artist and graphic designer—displays her artwork for sale in the tasting room of Black Mesa. Wanting to share her talent, Lynda hosts an "Art by the Glass" class where winery patrons can try their hands at creating their next masterpieces while also enjoying a glass of their favorite vino.

Cooperation is the key word among vintners in New Mexico, and no one exemplifies that better than Jerry. He is now the winemaker for the nearby Santa Fe Vineyards, which is a branch of the Estrella Del Norte Vineyard group, in addition to his role as owner of Black Mesa.

Whenever possible, Black Mesa Winery makes extra efforts to go green. The recycling of everyday products, a drip irrigation system, utilizing foliar sprays instead of commercial fertilizers, the collection of runoff and rain

waters for use in irrigation and incorporating grape skins and seeds from the crush for compost not only save the winery money but also protect the environment from further damage.

It is its attention to detail that makes Black Mesa Winery the largest winery on the meandering northern Rio Grande.

Don Quixote Distillery and Winery

Don Quixote Distillery and Winery describes itself as "a craft distillery and boutique winery specializing in limited-production, high-quality spirits, ports, and wines for people who appreciate the very best." It takes produce grown in New Mexico and creates products with a distinct southwestern flair. Established in 2005, Don Quixote takes pride in using natural, eco-friendly green manufacturing philosophy in utilizing the resources surrounding it.

Harkening back to the origins of New Mexican sacramental wine, Don Quixote offers Angelica. Made traditionally by blending unfermented juice with Don Quixote Muscat brandy, the Angelica is aged in French oak barrels using the Spanish Solaria method to yield a wine that is 20 percent alcohol by volume. Elegantly presented in an Italian glass bottle, Angelica sports a label featuring El Santuario de Chimayo, considered to be one of the holiest places in the state. The winery describes this wine as "the angel's nectar." and owners/master distillers Ron and Olha Dolin are proud to run one of only a few wineries that produce this delectable product.

Using locally grown corn, Don Quixote renders blue corn vodkas and brandies in its distillery. Don Quixote Distillery manufactures spirits under the trade names Don Quixote and Spirit of Santa Fe. The wine is produced under the trade names Don Quixote and Manhattan Project.

"Manhattan Project" harkens back to New Mexico's rich nuclear history and the important role it played in the formation of the world as we know it today.

Specializing in premium grape-, fruit- and grain-based spirits, Don Quixote Distillery and Winery combines science with distillation to produce Port and table-style wine. Don Quixote is proud to be the first and only fully licensed and bonded distillery in the state of New Mexico, operating as a subsidiary of Dolin Distillery, Incorporated.

Estrella Del Norte Vineyards and Winery/Santa Fe Vineyards

Sheltered beneath two-hundred-year-old cottonwoods, Estrella Del Norte Vineyard, established in 2008, offers its winery visitors a charming spot in which to stop, breathe in the crisp northern New Mexico air and enjoy a glass of their favorite wine.

The inspiration behind the winery's name came from owner Eileen Reinders's great-grandmother Estrella, who is depicted reaching for the North Star on the winery's label, which was designed by renowned New Mexico artist Amado Peña Jr. Art is a huge aspect and influence of Estrella Del Norte Vineyard, which houses a resident art gallery on the winery grounds.

A European-style garden sprinkled with sculpture by Siri Hollander and artwork by the Waxlander Galleries, which features New Mexican artists, is sure to get your creative juices flowing as you stroll past quaint flower gardens that feature over one hundred heirloom roses and restful ponds on your winery tour.

Sister to Santa Fe Vineyards, Estrella Del Norte enjoys the winemaking efforts of Jerry Burd of the Black Mesa Winery in partnership with co-owner Richard Reinders, who states, "This partnership gives Santa Fe Vineyards a new energy in winemaking and customer service."

Both wineries feature the distinctive artwork of such artists as Amado Peña Jr., Carrie Fell, Bruce King and Virginia Maria Romero for their labels. After thirty years of business, the artwork by Amado Peña Jr. for Santa Fe Vineyards is described as "a key plank for their heritage."

The Santa Fe School of Cooking offers classes for eager participants periodically during the year at Estrella Del Norte on the wood-fired oven and grill. The winery is also a coveted stop on the New Mexico Wine Tours and Enchanted Journeys de Santa Fe programs, which provide transportation and wine tours of the area.

The beautiful grounds, vineyards and arbor of the winery provide a perfect setting for any outdoor event, from weddings and holiday parties to reunions.

Eileen Reinders asserts that the New Mexico wine industry is capable of going toe-to-toe with any wine from around the world. The winery's Pinot Noir, its signature wine and one of Estrella Del Norte's twenty labels, won a gold medal in the prestigious Finger Lakes International Wine Competition. New Mexico is the only state where every single wine entered has medaled in the wine competition.

"Our wines are a blend of legend and innovation."

Eileen and Richard Reinders, owners of Estrella Del Norte, proudly display their award-winning wines. *Courtesy of the author.*

Richard Reinders, owner and winemaker of Estrella Del Norte, is striving to drum up more support, to get more people excited and draw more recognition for the New Mexico wine industry as a whole. Reinders envisions a "field-to-table" aspect. Eileen's vision of the future is to "keep their eyes on the goals, keep it fresh and take the winery to a new level in customer service, continuous improvement and excellence."

"Take a dream and go with it. All things are possible," is the motto of Estrella Del Norte Winery.

As the largest northern New Mexico grape grower, Estrella Del Norte Vineyards and Winery has two other vineyards, located in Santa Cruz and Nambè, for a total of nineteen acres of vines to provide grapes for its labels.

Along with the handcrafted vinegars and olive oils offered by the winery, it also features fortified wines exclusive to the Estrella Del Norte Winery. First is Luna Pera Especial, a pear wine. Second is Geronimo's Gold, an apple wine, and the third and final is Holy Molé, a truly unique vintage composed of a red Zinfandel blend, natural almonds, chocolate and locally grown Chimayó chile. Holy Molé embodies the true essence of New Mexico in one glass.

A visit to Estrella Del Norte Vineyards and Winery will bring you peace and let you forget that the world outside its gates exists as you are tended to by the warm and friendly staff and owners.

La Chiripada Winery & Tasting Room

Brothers Michael and Patrick Johnson hope you will consider your visit to La Chiripada Winery & Tasting Room a "stroke of luck," as their name translated from Spanish implies. Described as counterculture transplants from California in the 1970s—an ex-Jesuit apprentice and ex-potter, respectively—the brothers set out to follow their passion of winemaking.

The beautiful Rio Embudo Valley of northern New Mexico is the perfect setting for the winery, established in 1977 with the planting of hearty hybrid grape varietals. The La Chiripada name was adopted from the original ranch on which the winery is now located. Using the Spanish traditions, the Johnsons built the winery in 1981 using adobe brick and large wooden ceiling beams called *vigas*, filled in with small sapling logs called *latillas*, to give a distinct Spanish-southwestern style to the oldest winery of northern New Mexico.

Along with neighbors Jasper and Orlina Tucker, who established Rio Embudo Vines in 1983, La Chiripada produces twenty to thirty tons of grapes each season. La Chiripada's signature wines, Special Reserve Riesling and Rio Embudo Red Reserve Selection, are made from the grapes grown in its vineyards, while other grapes that cannot withstand the harsh northern winters are purchased from the Mimbres Valley in southern New Mexico. At 6,100 feet, only the most robust vines will survive the short growing season and unpredictable frosts.

Consistently voted the "Best Winery in New Mexico," La Chiripada strives to remain hands-on during the entire process, from planting the vines to the final bottling, to produce an award-winning wine that is a wonderful example of what New Mexico can offer.

Patrick Johnson is quick to add, "The wines range in style from dry, barrel-fermented whites to delightfully fruity, picnic-style wines and cellar-quality reds."

After over thirty years in the wine industry, Patrick and Michael have turned over the winemaker role to the capable hands of Patrick's son, Josh Johnson. Combining the grapes from the Mimbres Valley and its own vineyards, La Chiripada produces more than fifteen styles of award-winning wine, including Chardonnay, Riesling, Cabernet Sauvignon and Merlot, with the 2007 Cabernet Sauvignon as its pick for the best winery offering.

La Chiripada is excited to offer its wines at its winery in Dixon, New Mexico, as well as in the recently opened wine tasting room located in Taos on Bent Street.

Vivác Winery

Specializing in complex reds, Vivác Winery is touted by *Wine Enthusiast* magazine as "the highest rated red wine producer in New Mexico's history." Brothers Chris and Jesse Padberg, along with their respective wives, Liliana and Michele, set forth on a quest in 1998 "to make the best wine possible and have a good time doing it."

Vivác Winery is nestled in the mountains of northern New Mexico near the tiny town of Dixon. Typically an area known for its apple orchards, Dixon has seen the rise of many vineyards in the stunningly beautiful Embudo Valley, so much so that the Padbergs and other growers in the area are pushing for the valley to be named as an American Viticulture Area (AVA). With the eventual approval of this classification, the brothers expect the clout of New Mexico's wines to rise tenfold among wine lovers of the world.

As is true with many wineries in the state, Vivác sources the majority of its grapes from the New Mexico Vineyards in Deming, which is run by Paolo D'Andrea of the Luna Rossa Winery.

Described as "fresh, young, edgy and sophisticated" by nearly everyone who reviews them, the Padbergs strive to bring the winemaking tradition back to one of the oldest wine regions in the state. If you are looking for something out of the ordinary, then Vivác Winery is the place for you.

Vivác Winery is nestled in Dixon on the beautiful Embudo River Valley. *Courtesy of the author.*

Vivác boasts four wine professionals at the winery, including co-owner Jesse and his wife, Michele, as certified executive sommeliers. Having received their educations from the University of California–Davis, Chris and Jesse are continually pursuing knowledge in their chosen profession and are currently taking master's level courses from the International Wine Guild.

Vivác is a Spanish term meaning "high-altitude refuge," a description that perfectly describes the winery. At just over six thousand feet, Vivác is one of the highest-altitude wineries in the world.

Winemakers Jesse and Chris forge forward to create ever-better wines and the elusive "perfect wine." It is through the hard work involved in the actual cultivation of the grapes that the Vivác Winery men follow their true passion. Through this passion, Vivác Winery has captured national attention, being written up in *Sunset* magazine as a "winery to discover now" and in *USA Today* as having a "wine for everyday."

The ladies of the winery are no slouches themselves, as they too are very accomplished and vital to the success of Vivác Winery.

Michele, a New Mexico native, is the director of marketing and publicity and an executive sommelier. She also puts her theater and fine arts background to good use. Her contemporary artwork is available for sale at the winery store, and more recently, she has become Vivác's in-house fromegére, creating handcrafted cheeses under her Kissable Cheeses label.

Liliana, a native of Aguascalientes, Mexico, adds her expertise as a sommelier to the winery in addition to being the Tasting Room and Wine Club manager. Liliana, a former model, finds enjoyment as a photographer and chocolatier in her business Ek.chuah Chocolates. Her black-and-white photographs and handmade painted and formed truffles are available for purchase at the winery store.

Artist Jim Vogal, whose work is influenced by famous New Mexico artist Peter Hurd, created Vivác's label featuring the dramatic Barranca Blancas Mountain across the street from the winery. Michele Padberg joked that they like to refer to the impressive mountain as "Vivác Mountain."

Vivác Winery is proud to announce that it has opened a tasting room at the farmers' market in Santa Fe to provide even more wine lovers a taste of its unique wines.

Wines of the San Juan

Amid the rugged sandstone canyons in the Four Corners region, along the farthest northwestern border of New Mexico, Wines of the San Juan is the most isolated of the New Mexico wineries. Family based and run, Wines of the San Juan opened its doors in 2002.

David and Marcia Arnold moved to San Juan County fresh from running a Wisconsin dairy farm for twenty years. The Arnolds consider the Wines of the San Juan to be a boutique winery that offers a relaxed atmosphere to all who visit the tasting room with a wonderful view of the San Juan River *bosque* east of Bloomfield, New Mexico, which also runs through the property. The beautiful surrounding grounds have lured many couples to choose the winery as their wedding venue.

The Gewurztraminer—or, as it's pronounced in San Juan County, "girls are meaner"—reigns supreme at the Wines of San Juan winery. The Arnolds prefer producing this white wine, which is ready in six months, as opposed to reds, which can take up to a year.

The Wines of the San Juan has combined two great products into one with the introduction of wine jelly. An extremely popular concoction, the winery has difficulty keeping the jelly in stock.

The Wine of the San Juan website states, "Explore the rugged canyons and ancient ruins of the Pueblo and Navajo people, fly-fish the gold medal waters of the San Juan River and rejoice in the day at our winery, Wines of the San Juan."

Central Region

The Central Region is the fastest-growing wine-producing area of the state. This region also includes Albuquerque, the largest city in New Mexico, and is considered part of the Middle Rio Grande Valley AVA. Corrales, New Mexico, is now being referred to as the wine capital of the state.

Acequia Vineyards and Winery

The Corrales Valley, which was originally settled by Spanish, Italian and French immigrants, has seen the rise of many prosperous vineyards and wineries, one being Acequia Vineyards and Winery. Planted in 2001, Acequia has been planting grapes in selected spots around Corrales, giving it a total of five acres of grapes from which it produces its wines. The success of this method has led to the development of the Corrales Grape-Growing Co-op by Acequia vintner Al Knight.

Knight received his license in 2008, "with the help of the University of California–Davis and lots of friends and family." He proudly opened his winery and tasting room in 2010.

Acequia, pronounced AH-SAY-KEY-AH, is the Spanish word meaning irrigation canal. These canals or ditches are the lifeblood of any agricultural endeavor in New Mexico. It is through these ancient waterways that Acequia Vineyards' three thousand–plus vines are watered.

Knight carries on the long tradition of grape growing and wine production in Corrales that allows him to claim to have some of the best grapes and wines in the state. It is Acequia Vineyards and Winery's desire to provide a comfortable, peaceful place to enjoy a glass of one of its award-winning wines, and its owners are more than happy to educate the curious on the art of the grape.

Anasazi Fields Winery

Water is the lifeblood of any agricultural region, bringing the nutrients necessary to sustain crops. Referred to now as the Ancient Puebloan People, the Anasazi knew this as well. Anasazi Fields Winery at the western edge of the old village of Placitas is surrounded by ancient spring-fed irrigation systems utilized by the Anasazi who farmed the Placitas Valley more than a thousand years ago. Placitas is described in historical documents as a beautiful village with orchards and vineyards close to each house. The village has changed little over the years.

Anasazi Fields Winery is located on top of an ancient Anasazi cornfield, and as the label depicts, there are petrogylphs found on the outcropping above the winery

Today, the Placitas village is just minutes away from the hustle and bustle of Albuquerque, but it retains its quaint character with Pueblo-style architecture and rustic landscaping. Locals describe the village as a place just far enough from and close enough to everything.

Anasazi Fields Winery mainly produces fine dry table wines from fruit and berries other than grapes, but it has recently begun to dabble in grape wines with a twist. The twist is usually the addition of peaches, cherries, plums, raspberries, cranberries and apricots to an established wine, such as a Chardonnay, to produce an off-dry sipping wine that pairs well with pastas and salads.

One particular blend of Syrah, Black Malvasia and Gamay grapes infused with plums, cherries, figs, black pepper and Mediterranean spices produced by a method self-named by owner/winemaker Jim Fish the co-sequential fermentation process, has caused a sensation. Synaesthesia—which, according to *Webster's New World Dictionary*, means, "A sensation felt in one part of the body when another is stimulated"—certainly lives up to its name.

All of Anasazi Fields' wines are aged in oak barrels for two to three years before they are bottled, which helps the slow, cool, sugar-starved fermentation process. The winery makes what can only be described as unusual dry fruit wines that owner Jim Fish suggests people try before they buy. The wine is not for every palate, but the wines have been a dream of the winemaker since his days as a chemical engineer at Sandia National Laboratories. Along with his other hats, Fish is also known as being a spokesman for environmental causes, especially land conservation.

Through the words of Jim Fish, winemaker, woodcarver and poet of Anasazi Fields Winery, you certainly get the essence of the history and

beauty that surrounds the vineyards and how it is translated into the quality of their wines.

Be aware as you travel through the village of Placitas because there will be no sign for the winery on the main road. Call ahead for directions to 26 Camino del Los Pueblitos in Placitas.

Anderson Valley Vineyards

A pioneer in the New Mexico wine industry, Anderson Valley Vineyards, which was once located in the central Albuquerque area, was instrumental in developing the northern regions of New Mexico for wine production. Patty and Maxie Anderson, of hot-air balloon royalty, started their vineyard in 1973. Sadly, the winery closed following the 1983 death of Maxie in a balloon accident. Although Anderson Valley Vineyards is no longer in business in the Upper Rio Grande Valley, the modern winemakers of New Mexico owe the Andersons a debt for forging new winemaking ground in the New Mexico wine industry.

Casa Abril Vineyards and Winery

With a four-hundred-year-old family legacy to live up to, Raymond and Sheila Vigil and family strive to provide a satisfying product at Casa Abril Vineyards and Winery. The establishment embodies the Spanish family and winemaking tradition in all that it accomplishes.

Dating back to the Vigil and Romero families of colonial Spain and active in the New Mexico wine industry as long as it has been in existence, the Vigils' winemaking excellence is no easy honor to carry.

Raymond Vigil is proud to say that "combining the music of laughter, the closeness of family and the desire to produce a successful product, Casa Abril Vineyards and Winery is not just another glass of fragrant, well-rounded wine; it is a Spanish family experience."

Casa Abril Vineyards and Winery began in 2001, when family and friends planted by hand the first one hundred Tempranillo grape vines in the rich soil. Every year, more and more grapes are added, including *Vinifera* Tempranillo and Malbec varieties, to the already established Spanish and Argentinean grapes, creating a variety of special niche wines.

"Producing American Tempranillo and Malbec wines energized by our caring hands and imbued from root to peppery finish by the devotion and joy of our Spanish heritage, Casa Abril Vineyards and Winery brings to your table something at once as old as the conquistadors and as new as our freshly bottled Rosé," Raymond Vigil explains.

Casa Rondeña Winery

As you pull into the adobe-walled estate of Casa Rondeña Vineyards and Winery, you will swear you have been transported to a Tuscan villa deep in the heart of Italy. The evenly rowed vineyard graces the front of the Los Ranchos de Albuquerque estate, allowing those who enter a quiet respite from the hustle and bustle of the city that surrounds it.

Vintner John Calvin—who studied world music, from the classical music of India to the southern Spanish Flamenco guitar—forged Casa Rondeña Winery from his own plans into one of the most beautiful wineries in New Mexico. A native of the Rio Grande Valley, Mr. Calvin instills a philosophy of respect and passion for the complex elements of nature into the care of his vines and winemaking.

Established in 1995, Casa Rondeña is a family operation stemming from the dreams of Calvin and his sons, Ross and Clayton.

"Casa Rondeña was never conceived as just a winery, but rather as a center of gravity for the arts," Calvin explains.

Calvin credits his Italian-born wife, Christina Viggiano, for bringing beauty and grace into their home and breathing life into the grounds of Casa Rondeña since their marriage in 2004. He feels it is Christina's influence that is reflected in the quality of wine offered by the winery.

The distinctive commemorative tercentennial bell tower of the tasting room harkens back to the architecture of Spain. The year 2008 saw much growth at Casa Rondeña, with the addition of the barrel aging and storage facility and the Founder's Rotunda. Each was built to increase production capabilities and provide a stunning site for special events.

The romantic, elegant setting of the winery is a perfect scene for weddings, elaborate events and casual get-togethers. The personal home of the Calvins has been recently given over to the winery in 2010 for the formation of the 1629 Wine Club. The title of the club pays homage to the historic beginning of wine in New Mexico.

John Calvin states, "We invite you to visit the tasting room, sample our wine and be prepared to be inspired and transported to a time gone by. Enjoy the winery, love the wines."

Named Best Vintner by the readers of *Albuquerque* magazine in 2012, John Calvin strives to produce the best red wine in New Mexico. As an early founder of the state's wine industry, Calvin is putting his wines up against the best of California and winning medals. Casa Rondeña's Meritage Red—a Bordeaux-style blend of Cabernet Franc, Merlot and Cabernet Sauvignon—was awarded eleven gold and double-gold medals over the last three years.

"Winemaking is an artform that transcends cultural boundaries. Among music, art and architecture, winemaking is a prime example of a universal language like no other," says Calvin.

Corrales Winery

Although one of the relatively new wineries of the state, having been established in 2000, Corrales Winery proprietors Keith and Barbara Johnstone have an enthusiasm for the New Mexico wine industry that is as delectable as their Muscat Canelli. In the heart of the tiny village of Corrales, the winery draws you near as you drive past the neatly planted vineyard. Breathtaking views of the Sandia Mountains frame the vineyard for the perfect photograph.

A family-owned business, Corrales Winery states that it "specializes in finely crafting small quantities of rich, delicious wines, showcasing the fruit flavors of the grapes."

"Drink what you like and don't let anyone tell you differently," explains owner Keith Johnstone when asked which is the best wine for a person to drink.

The village of Corrales is situation on the historic Alameda Land Grant and is a region that has been inhabited by native peoples for 1,300 years. It has become known for its vineyards and winemaking. Corrales Winery is located along the National Scenic and Historic Byway used by early Spanish settlers.

Corrales Winery has a beautiful blend of Indian and Spanish architecture in which the Johnstones have paid attention to every detail. It is also with such great attention to detail that they handcraft their exceptional, award-winning wines.

Johnstone explains, "Starting with grapes grown in the New Mexico sun, we produce a selection of red and white wines for every taste."

Corrales Winery has received many gold and silver medals for its wines. For a small winery and a humble winemaker and owner, this is not only quite an honor but also unexpected. Johnstone, a Chicago native, came to Albuquerque, New Mexico, in the 1970s as an engineer for Sandia National Laboratories. While touring the surrounding countryside, Keith and Barbara Johnstone were lucky enough to happen upon a farmer who was selling his land. When the couple saw the view of the beautiful Sandia Mountains from the farm, they asked the obvious question: "How much?"

With the help and encouragement of fellow Sandia engineer, Henry Street of Ponderosa Valley Vineyard and Winery, the Johnstones began to cultivate grapes on their newly purchased six acres of land. "I began learning to read the vines. They are expressive in that sense. There aren't any great secrets to making wine, just patience. And don't screw it up, that's the trick," says Johnstone.

Taking courses at the University of California–Davis, Johnstone learned the art of winemaking, which he has taken to heart by producing wines that are of high quality while also providing great customer service.

A stop at the Corrales Winery will be both beautiful and educational. Keith Johnstone is well versed in the history of New Mexico wine and will be happy to enlighten his winery patrons of the wine heritage that surrounds them.

Gruet Winery

Known for its sparkling wines, the Gruet Winery label is recognized not only in New Mexico but also nationally and internationally. Originally from the Champagne region of France, the Gruet family has a long history in champagne-making reaching back to 1952.

Gruet et Fils was established in Champagne, France, by Gilbert Gruet, the family patriarch who was an architect by trade. It is said that Mr. Gruet was fascinated by wine and agreed to build a winery in exchange for a winemaking lesson. That lesson certainly paid off for the Gruet family.

During their search for the perfect grape-growing soil and climate in 1984, Laurent Gruet, along with his sister Nathalie and family friend Farid Himeur, discovered Albuquerque and the Truth or Consequences areas of

New Mexico. A year earlier, the brother and sister pair, with the help of Himeur, planted an experimental vineyard in Lordsburg, New Mexico, but they found the climate to be too hot for the Chardonnay and Pinot Noir varietals and sold the land.

The family then toured California, Texas and New York for potential vineyard locations, but they were lured back to New Mexico by European friends who were already in the winemaking industry there.

Natalie Gruet explained, "We were pretty charmed by the rugged beauty of New Mexico, and to see these lush vineyards in the middle of the desert was very intriguing."

The cool evenings slowed the ripening process and produced a pleasant, sharp acidity to the wine. After sending soil samples to France for analysis, the Gruets were enthused by the results and started to grow Pinot Noir and Chardonnay grapes.

Laurent Gruet, president of the Gruet Winery, has been quoted as saying, "New Mexico is a great place to grow grapes. The land is inexpensive, weather conditions are ideal and the dry climate means less disease."

Because only wines made in the actual Champagne region of France can be called champagnes, Gruet Winery produces sparkling wines in the méthode champenoise. Gruet has been called a trailblazer for the New Mexico wine industry and has become the most successful winery in the state.

"It's always time for a little bubbly," is the unofficial motto of the Gruet Winery. An interesting fact is that the pressure in a typical bottle of sparkling wine is about ninety pounds per square inch, which is three times that of an average car tire.

Gruet Winery has received many accolades in publications, such as the *Wine Enthusiast*, *Sunset*, *Gourmet* and *New York Magazine*. Laurent's hope for New Mexico can be summed up by this statement: "We hope New Mexico will follow Oregon and Washington as a region known for its wines. That's both a good thing for the state and for us."

The Gruet family is a huge asset to the New Mexico wine industry, bringing their expertise and skills learned through many years of family tradition to their new adoptive home. Pronounced GREW-ÉH, the Gruet Winery offers Brut, Blanc de Noirs, Demi-Sec, Blanc de Blanc, Vintage Chardonnay and Pinot Noir from New York to Hawaii, introducing the United States to the fine sparkling and still wines New Mexico already has to offer. Of all the New Mexican wineries, Gruet has had the most profound impact on the United States' and the international wine markets' view of New Mexico wine. This influence has been a great benefit to the rest of the state's wine industry.

Guadalupe Vineyards

A tile likeness of Our Lady of Guadalupe greets all who pass through the adobe gates of the Guadalupe Vineyards, located at the foot of Mount Taylor, just one hour west of Albuquerque. Our Lady has certainly blessed the small vineyard named in her honor as the vineyard continues to flourish in the dusty surroundings.

Planted in 2000, the vineyards of Guadalupe produce three premium Alsatian varietals of Riesling, Muscat and Gewurztraminer wines grown on the family estate. Located at 6,400 feet above sea level, Guadalupe Vineyards is one of the highest-elevation vineyards in the world.

"Our wines are a result of high-altitude, volcanic soils from the San Mateo Mountains, the marriage of local Spanish springs and the fine Old World winemaking techniques," owner Antonio Trujillo says.

Antonio Trujillo, a former Franciscan priest, and his wife, Lucinda, have nurtured the rich soils at the foot of Mount Taylor along the famous Route 66 to produce a wide variety of award-winning grapes, some of which were still growing on the property even after years of neglect by the previous owners.

Trujillo says of his 2009 Riesling that "this wine delivers a very pure, mouthwatering edge of lemon and grapefruit flavors, with a long clean finish of green apple. It beams of acidity that keeps the focus and persistence of flavors going. Finally, it has a wonderful expression of citrus blooms."

Milagro Vineyards

The distinctive label of Milagro Vineyards, featuring a tuxedo-clad, bow-tie and monocle-wearing potbellied pig named Wilbur, is an eye-catcher. Rick and Mitzi Hobson, the owners of Milagro Vineyards, make handcrafted wine in the village of Corrales and, at one time, ran a rescue for overly portly potbellied pigs that were no longer wanted by their owners. They no longer rescue the pigs, but they keep up the winemaking and have taken on the new cause of Boston terrier rescue.

It was a fateful 1980 trip to California's Napa Valley that changed their lives forever. It was there that they fell in love with wine. Five years later, they planted a vineyard, and Rick, a chemical engineer, became a winemaker in another three.

Being a chemist, Rick knew that strict attention to technically correct formulas was essential to traditional winemaking but worried that such strictness might detract from the quality of the grape.

"Handcrafted from vine to wine" is Milagro Vineyard's motto. Concentrating mostly on Zinfandel, Merlot and Chardonnay, the Hobsons age their wines in French oak, which they feel showcases New Mexico's terroir.

In an article written by Shirley Nelson for *New Mexico Wino*, Hobson is quoted as saying, "Every time you touch the wine, I feel you lose something. I see winemaking as being a caretaker. The wine is really the reflection of climate, terroir. Raise the best grapes possible and let the wine be what it is."

Milagro Vineyards, although a small operation producing wines not widely available in the marketplace, has received many accolades from critics and colleagues alike and is touted as the winery to watch.

Ponderosa Valley Vineyards and Winery

Henry Street, owner of Ponderosa Valley Vineyards and Winery, is the unofficial historian, spokesperson and godfather for the New Mexico wine industry with good reason.

First coming to the Ponderosa Valley in 1976, the Streets purchased a small three-acre camping retreat but soon noticed the many small vineyards dotting the valley's countryside. After taking a grape-growing class, Street was ready to begin his own grape journey at the altitude of 5,800 feet.

Located on the southern slope of the red-striated Jemez Mountains, Ponderosa Valley Vineyards and Winery has been serving wine since 1993. The vineyards were planted in 1978—mostly with Riesling, thanks to the urgings of California vintner Jim Concannon—to make Ponderosa the largest Riesling vineyard in New Mexico. It offers three distinct styles of Riesling by timing the picking of the grapes to make use of different ripeness levels, with award-winning results.

Clippings from Concannon's Livermore Valley vineyards were planted in the volcanic ash deposits of the Ponderosa Valley Vineyards and Winery in the initial planting, soon to be followed by more Riesling cuttings from the Monterey Vineyard of the Wente Brothers in Monterey, California.

French hybrids that proved to be hearty enough to withstand the elements at 5,800 feet were added to the vineyard, and a Pinot Noir clipping taken from the mother vineyard at the University of California–Davis was added to supply Ponderosa's second signature varietal.

The first harvest was in 1982 and was purchased by neighboring winery La Chiripada, which produced an award-winning Riesling from its acquisition.

As with many California vines, cold-hardiness was not the University of California–Davis vines' virtue, so Ponderosa Valley Vineyards has replanted much of its Riesling vines with a clone 90 from the Washington State Inland Desert Vineyard, where the climate is closer to that of the Ponderosa Valley.

Recently sourcing Tempranillo and Cabernet Sauvignon grapes from New Mexico Vineyards in Deming, Street is confident that he has two more award-winning wines on his hands following in the footsteps of his double gold medal–winning 2008 Tempranillo.

Street makes a circuit to civic groups around the state, telling the history of New Mexico wine, as well as giving classes on winemaking—truly keeping the art of New Mexico winemaking alive.

Once at the winery, you will no doubt notice the fire engine–red classic 1951 GMC pickup parked in front. The words emblazoned in gold paint on the tailgate—"Get Thee to a Winery!"—will surely bring a smile to your face.

Tierra Encantada Winery

Tierra Encantada Winery proprietress Pat Coil takes pride in educating her patrons about wine. "We want you to leave with at least one wine fact that will amaze your friends and increase your enjoyment of wine," she says. Located in Albuquerque's South Valley, just a short drive from Old Town, Tierra Encantada, meaning "enchanted land," is proud of the quality of its unique, single-vineyard wines.

Tierra Encantada Winery's motto, "Taste the enchantment, fines wines for fine spirits!" sets the mood for your visit.

Grapes grown in the sun are much sweeter than those under canopies. At Tierra Encantada, testers check the grape clusters as they walk through the rows of vines to ensure the grapes have the consistent taste they desire.

Grown in vineyards fifty miles south of the winery at its San Vicente Vineyard in Veguita, which is close to the location of the very first vineyards of northern New Mexico, red and white *Vinifera* grapes make up the majority of its wines. Bordeaux varietals include Cabernet Sauvignon, Merlot and Sauvignon Blanc, and the Rhone varietals include Cabernet Franc, Syrah, Mourvèdre and Viognier. The Spanish Tempranillo varietal is a new addition. French hybrids, such as Chambourcin, Seyval, Vidal and Villard, are purchased from growers in the South Valley and around Albuquerque as well.

Bottling well over one thousand cases of wine annually, Tierra Encantada is proud of its signature wine: Atrisco Sunset.

Tierra Encantada wines have received many medals in local, regional and national competitions. It is its goal to add many more to its collection.

"Don't be surprised if we bend your ear about the grapes in our wines and our successes and difficulties in producing them," says Coil with a knowing smile.

SOUTHWEST REGION

The Southwest Region includes the Mimbres Valley and Mesilla Valley AVAs, which are the sites where the majority of New Mexico's grapes are grown.

Amaro Winery

A family-owned winery, Amaro opened its tasting room doors in 2009, featuring its 2007 Cabernet Sauvignon and a dessert wine, Angelica. Since opening, its wines have won seven medals in the New Mexico State Fair. Amaro Winery presents live music on the weekends and will sponsor classes on cheese, butter, yogurt and ice cream making throughout the season.

In the heart of Las Cruces, New Mexico, Amaro Winery is proud to be a part of the Old West ambiance that surrounds it.

Winemaker, Benjamin Maier of Germany produces all the wines on site from grapes grown in southern New Mexico. Maier, who comes from a long line of winemakers, opened Alamosa Cellars, making good friends along the way. The Denton family was one of those friends, and when Maier approached them with the idea of opening a winery, they jumped on board. Once ideas were formulated, the group worked quickly to turn the dream into a reality.

The name Amaro was decided on when the owners learned the name of the grape variety Negro Amaro, which originated in southern Italy. It opened in 2009 with nine wines, including a silver medal winner from the New Mexico State Fair wine competition, and was off to a great start. Today, its signature wine, Refosco, is a gold medal winner.

In December 2010, Amaro bought a new bottling machine and began construction of a new production building. In 2011, Amaro Winery gained

recognition in the June issue of *Sunset* magazine, and it is excited for what the future may hold.

Black Range Winery/Vintage Wines

The foothills near historic Hillsboro, New Mexico, provide the perfect setting for the vineyards that produce the grapes for the Black Range Vineyards and Winery owned by Brian and Nicki O'Dell.

"We are a small vineyard gone Wine Bar, proudly serving the best local wines from the Land of Enchantment," explained the O'Dells.

Vintage Wines, the tasting room for the Black Range Winery, located in Mesilla, New Mexico, calls itself the "velvet underbelly of Mesilla." Close to the historic Mesilla Plaza, you can drink in the rich ambiance as you sample over fifty New Mexico wines, including its own Black Range label.

A part of the tasting delight is a selection of light tapas and fine cigars. Live music on the patio during the weekend tops off the deal to ensure you enjoy your wine tasting experience.

Blue Teal Vineyards

Located in the scenic Pyramid Valley east of Lordsburg, New Mexico, Blue Teal Vineyards is ever expanding its acreage. Currently plans are underway to expand to 220 acres, with one thousand vines per acre, giving Blue Teal a strong foothold in southern New Mexico. The migratory blue-winged teals that make their home in a pond on the property are the vineyard's mascot and namesake. The owners, the Lescombes family of St. Clair Winery fame, like to relate how this migratory pattern is much like their own from France to the United States.

The Blue Teal Vineyards White Merlot and White Zinfandel have acquired a large fan base within the state.

Fort Selden Winery

One of New Mexico's newest wineries (opened in 2012), Fort Selden Winery honors the rich Civil War history of the state. The ruins of the Fort Selden State Monument and the fort museum are located across the road from the winery, providing visitors to the winery a means in which to step back into

Fort Selden Winery, one of New Mexico's newest wineries, has wonderful views of the Robledo Mountains. *Courtesy of the author.*

the past. Fort Selden, which once housed the famous Buffalo Soldiers, was in operation from 1865 to 1891. The fort was also used in a peacekeeping capacity for the varied cultures that inhabited the area, and it is now open to the public for interpretive tours.

Groundbreaking for the mom and pop vineyard began in 2005, as bulldozers cleared the indigenous mesquite bushes and cacti from the land to reveal rich sandy soil, perfect for planting grapevines at the feet of the beautiful Robledo Mountains.

The first planting consisted of Shiraz, Cabernet Sauvignon and Barbera grapevines provided by the New Mexico Vineyards in Deming, New Mexico. A combination of birds, grasshoppers, June bugs, raccoons and skunks have played havoc with the new vines to make the first year of production challenging, but owners Desiree and Franklin Simon, who came from the Netherlands to Las Cruces, have persevered to produce, as their slogan says, a "wine worth defending."

Fort Selden Winery is described as a "family-owned winery that focuses on creating excellent wine and enjoying life."

At the base of the Robledo Mountains, Fort Selden Winery offers magnificent views of the surrounding valley from the picture windows in the tasting room. The Simons are a delight to talk to and are more than willing to discuss the trials, tribulations and ultimate successes of the wine industry with their tasting room customers.

New Mexico is strict in its rules for the wine industry, making it difficult to obtain a license right away for many new wineries. It took Fort Selden Winery five years to obtain its license, but when you visit and taste the results of the Simons' labor of love, you will agree it was well worth the effort.

La Esperanza Vineyard and Winery

Heritage embraces La Esperanza Vineyard and Winery. The winery and vineyards stand on inherited family land and in original structures, giving a special meaning to the operation. "A little bit of wine with a lot of heart" has become La Esperanza's motto.

La Esperanza is truly a family business and a labor of love. David and Esperanza Gurule are the owners and vintners of this special land, described by most as a "touch of Tuscany." The ninety-year-old structures that are the foundation of La Esperanza Vineyard and Winery lend a touch of romance and Old World beauty to the surrounding forty acres that belonged to the family matriarch, Antonia Orosco.

On land so rich with history, it is easy to picture the early Mimbreno Indians, Hispanics and Anglo-Saxon settlers who preceded you at that spot.

Esperanza can mean hope, dream or aspiration, something La Esperanza Vineyard and Winery took to heart in its little piece of heaven tucked away in southwestern New Mexico.

La Viña Winery

As the oldest winery in the state of New Mexico, La Viña Winery is responsible for the revival of the wine industry we know and enjoy today. Originally started by Dr. Clarence "Kiki" Cooper, an associate physics professor at the University of El Paso, who planted a few vines in his front yard in the tiny village of Chamberino as an experiment, La Viña steadily

grew. Cooper increased the number of vines in 1977 to the point where the yield was so great he opened the winery.

The Organ and Franklin Mountain Ranges are the view from the hand-forged front gate of La Viña's front courtyard where winery patrons are encouraged to relax at the small tables or take a leisurely stroll through the twenty-four acres of vineyards. Ken and Denise Stark bought La Viña from Dr. Cooper when he made them an offer they couldn't refuse and began winemaking out of their garage.

The original idea was to move La Viña Winery to Albuquerque or California, but the current location was highly successful; so the Starks decided to stay put and build the winery into what it is today: a forty-five-acre estate, complete with tasting room, patio and state-of-the-art winemaking processing building and equipment.

Host of two major wine festivals and numerous small events, the winery has drawn attention to the sleepy town of La Union, which is only twenty minutes from the Texas border, by attracting at least six to eight thousand tourists into the area. Since the Starks opened their romantic, Old World–style tasting room on July 4, 2002, La Viña Winery has thrown a huge Fourth of July bash to celebrate not only its anniversary but also, of course, the birthday of the United States. With one of the celebrations being the Alzheimer's Walk, La Viña Winery is immensely proud to say it has raised $200 million for the treatment of Alzheimer's since 1989.

La Viña Winery is also proud to produce all of its 3,500 cases of wines per year on the premises, a fact that is extremely important to the Starks.

Ken Stark is La Viña's winemaker and describes his vision of his winemaking style as an "Italian style with lots of time in the barrel." He likes the wine to have "a little more acid," and he prefers to "to macerate wines fairly long."

The Starks' intention with their vineyards is to ensure that their supply of grapes for full production is available at a reasonable rate. Watered by the Rio Grande, La Viña Winery is the only estate-bottled winery in New Mexico or Texas.

Starting his winemaking career with the Anderson Valley Vineyards of Albuquerque in 1988, Stark pays forward his expertise as he is quick to help the vineyards surrounding La Viña Winery. He believes that terroir comes from the climate not the soil, and his approach has certainly proven successful as the self-designed La Viña Winery continues to find success as the oldest continually run winery in New Mexico.

Luna Rossa Winery

Talk to any vintner in the state, and you will hear time and time again of how Paolo D'Andrea and his Luna Rossa Winery saved the New Mexico wine industry. Hit hard with killing, late-season frosts for two seasons, 50 to 90 percent of the northern crops were lost, leaving a desperate situation. The statewide killing frost hit Luna Rossa hard, and the winery lost half of its grapes in 2011.

Neighborly can best describe the attitudes of Paolo and Sylvia D'Andrea. In order to save the wine season for his northern neighbors, D'Andrea cancelled large-order contracts for his grapes from surrounding states in order to concentrate on the wineries struggling in New Mexico. Without his willingness and cooperation, there would have been a great shortage of wine in 2010 and 2011 that would have greatly damaged the already fragile industry.

Luna Rossa Winery, which means "red moon," is the largest winery in the state, encompassing three hundred acres of prime land in the Mimbres Valley, which includes a unique grapevine nursery.

D'Andrea has been a mentor to many of the boutique wineries of the state, bottling their crops using his large winemaking facility. Balzano Vineyard, which is located in Seven Rivers, New Mexico, and produces some of the best wines in the state by a small winery, relies on Luna Rossa for its processing as does the Cottonwood Winery, owned by Dale and Penny Taylor, found in southeastern New Mexico.

"In New Mexico, the wonderful thing is that you can grow all different types of grapes in this climate," D'Andrea says.

D'Andrea's family has been making wine for four generations in the north of Italy. D'Andrea has carried on the tradition in America for

Just outside Deming, New Mexico, Luna Rossa Winery is steeped with four generations of family winemaking tradition. *Courtesy of the author.*

the past twenty-five years, much of which, he admits, was spent on the learning curve.

Nini is Luna Rossa's signature wine. It is a blend of Dolcetto, Rebbiolo, Barbera, Sangiovese and Refosco wines and named by D'Andrea himself. Meaning "last one of the family," Nini carries a special place in D'Andrea's heart as this was his family nickname for himself.

New Mexico Vineyards

The largest vineyard company in New Mexico, near Deming, supplies over fourteen wineries with grapes. Swiss owned, New Mexico Vineyards is managed by Paolo D'Andrea of Luna Rossa Winery.

Rio Grande Vineyard and Winery

Gordon Steel's roots run deep in his beloved Mesilla Valley at the foot of the magnificent Organ Mountains. Born in Hatch, New Mexico, the home of the world-famous Hatch chile, Steel is proud to have a long lineage in the state. His ancestors settled here from Northern Ireland in the late 1880s.

Family tradition, both in the community and business, is extremely important to the Steels, who have played a major role in southern New Mexico's history.

Steel states on his website that while in the United States Air Force, he and his wife, Sandi, traveled the major wine regions of the world dreaming of their own chance to start a winery in the States. This dream became a reality in 2004 when the Steels returned home to New Mexico and planted a ten-acre vineyard that included eight European varieties of grapes.

Gordon had always had an interest in grape growing and beekeeping, as the two seem to make a perfect pairing. He was the president of the New Mexico Bee Keeper's Association in 1993 while stationed at Kirtland Air Force Base in the Albuquerque area, and he is listed as the current president of the New Mexico Wine Growers Association.

Introduced at the early age of thirteen to winemaking by his father, Steel studied vineyard management and winemaking at the University of California–Davis and Washington State to finely hone his skills. With its first harvest in 2007, Rio Grande Vineyard and Winery has enjoyed a steady increase in production each year since. The tasting room, complete with

vintage photographs, was opened following Gordon's retirement from the air force in 2009.

Rio Grande Vineyard and Winery boasts ten acres of vines planted in the rich soil along the Rio Grande Valley. The view of the Organ Mountains from the picture window inside the tasting room or from the patio outside is breathtaking. Rio Grande Vineyard and Winery is a huge part of the wine industry in southern New Mexico, where it continues to promote the industry and encourage future vintners by employing local college students who share the same passion for the grapes.

Southwest Wines

Composed of multiple brands, Southwest Wines features wines produced by the D.H. Lescombes family. Labels included are St. Clair Winery, Blue Teal, D.H. Lescombes and San Felipe. These wines are produced in separate wineries all under different labels but are from the same family unit. Branching out recently to Arizona, members of the Lescombes family have opened the Kokopelli Winery in Chandler.

The secondary labels that Southwest Wines is known for include Plum Loco, Summer Peach, Wine-a-Rita and Chocolate d'Vine, which cater to the novelty market and those wine lovers with sweet palates.

St. Clair Winery

Included in the Southwest Wines family is St. Clair Winery, New Mexico's largest winery. St. Clair boasts having over six generations of winemaking experience under its belt to enhance its four labels, which produce forty wines. As a member of the Mimbres Valley AVA, St. Clair makes its wines from the grapes grown in the 220 acres of vineyards that are planted in the rich, loamy soil near Deming, New Mexico, and across the state of New Mexico.

St. Clair is proud to not only be New Mexico's largest winery but also to rank sixty-ninth in the entire United States.

As written in the winery's history on the St. Clair Winery website:

> *Hervé Lescombes, patriarch of the Lescombes wine family, settled in southern New Mexico after years of successful wine making in Burgundy,*

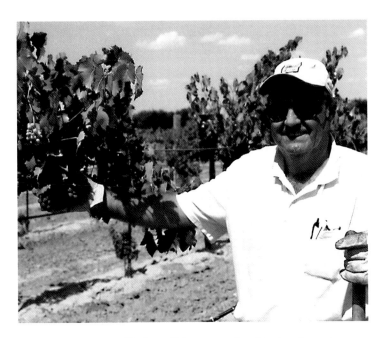

Dale Balzano, owner of Balzano Winery, examines his vines located at Seven Rivers, New Mexico. *Courtesy of the author.*

St. Clair Winery offers delicious wine under many labels as New Mexico's largest winery. *Courtesy of the author.*

France. He carried on his family legacy by planting a small vineyard influenced by European viticulture near Deming, New Mexico.

Tom Dinardo for *Inc.* magazine expounds praise for St. Clair as he writes:

From this vineyard, only the highest quality hand-selected grapes are destined to become D.H. Lescombes wines. Showcasing an Old-World approach to winemaking, focused on balance and subtlety, D.H. Lescombes wines are dedicated to French oak maturation and are handcrafted with traditional techniques.

Hervé Lescombes and his wife, Danielle, owned and operated the Domaine de Perignon Winery in the heart of the French wine country as fifth-generation winemakers. A trip to the United States proved to be an opportunity for a new beginning after many years of success in France.

St. Clair grows Cabernet Sauvignon, Chardonnay, Sauvignon Blanc, Zinfandel, Syrah, Muscat and Malvasia Bianca, along with a few others, to produce over 200,000 cases of wine a year for the winery.

Run today by Florent and Rebecca Lescombes, St. Clair Winery is proud to be a huge contributor in bringing New Mexico wine to the forefront of the world. With two bistros in both Albuquerque and Las Cruces, St. Clair has the perfect venue to pair its wines with delicious New Mexico dishes.

SOUTHEAST REGION

The Southeast Region is included in the Tularosa Basin AVA. Drink in history as you follow the Billy the Kid National Scenic Byway and Highway 70 through the diverse wine country of southeastern New Mexico.

Arena Blanca Winery

Called a true agricultural marriage, Arena Blanca Winery sits on the McGinn Pistachio Tree Ranch between Alamogordo and Tularosa, New Mexico. The ranch is home to the "World's Largest Pistachio," a thirty-foot metal sculpture of a giant pistachio, which was raised as in memory of original owner and founder Tom McGinn by his son and current owner, Tim McGinn.

The idea for such a massive tribute came from the many road trips the McGinn family took over the years to see oddities such as this. "These pieces of Americana I remember visiting were built by inspired Americans who loved what they did and wanted everyone to know it. I think that was my dad," Tim McGinn said with pride. It is Tim McGinn's hope that the large pistachio will become a roadside attraction sought out by other road-warrior families seeking to make lasting memories.

Known mainly for their pistachios, the McGinns also have fourteen acres of vineyards from which they produce thirteen award-winning wines, including their signature Pistachio Delight wine, which is a marriage of their two loves. With over 6,500 grapevines offering Chardonnay, Cabernet Sauvignon, Merlot, Zinfandel and Gewurztraminer grape varieties, Arena Blanca Winery blends its grapes with other locally grown fruits, such as cherries, apricots, apples and pomegranates, with delightful results.

Arena Blanca means "white sands"—paying homage to the natural phenomenon of White Sands National Monument. Another "world's largest" attraction, the 275-square-mile gypsum dunefield lies close to the winery's vineyard.

The Tularosa Basin is home to rich loam soil, mild climate and spectacular mountain views—the perfect spot for vineyards and pistachios.

Balzano Winery

Balzano Winery is housed in the magnificently restored, circa-1892 Trinity Hotel that once housed the First National Bank in downtown Carlsbad, New Mexico. Wines from the Luna Rossa Winery, as well as its own label, Spirits of Seven Rivers, are featured predominately at the Trinity Hotel owned by Dale Balzano and his wife, Janie.

The Balzano Vineyard is cradled on three sides by pecan orchards in Seven Rivers, a small hamlet north of Carlsbad on Highway 285. Grapevines are planted in land that bore witness to the Old West at its most violent time. Once a domain for outlaws such as Billy the Kid (who stirred up trouble as he passed through), Seven Rivers was reported to have removable saloon doors that doubled for stretchers once a cowboy met the business end of a Colt revolver.

Dale Balzano named his vintage Spirits of Seven Rivers after he, his family and staff experienced many strange happenings in and around the vineyard and the Trinity Hotel. Spirits had made a home in their company.

Lovingly restored by the Balzano family and partners, the Trinity Hotel (circa 1892) houses not only a boutique hotel but also a favorite Carlsbad restaurant and winery. *Courtesy of the author.*

A cowboy, who seems to delight in walking through the walls of the processing warehouse at the vineyard, and an apparition of a small girl playing amongst the vines have been seen frequently by workers.

In order to build the nearby Brantley Dam State Park man-made reservoir, the Seven Rivers Cemetery was relocated a little over twenty miles north to Artesia, New Mexico, during which time each of the late 1880s graves of outlaws and townsfolk had to be opened and cataloged. This is thought to have disturbed the spirits, sending them back to their original homes.

It was suggested by the wine cultivator that Balzano perform a ceremony of protection in the vineyard to try and curb the ghostly activity. A dinner was cooked and eaten in the vineyard, a rose bush planted and an empty wine bottle buried bottoms up at the head of each row at Janie's suggestion. The spirits appear to have taken heed to the traditional Italian ritual and settled down some.

While examining a few of his ailing three- to four-year-old vines, Balzano quietly quipped, "You learn something new every year." An iron deficiency is suspected to be the culprit affecting only a select few vines. Treatment will be made and a new lesson will be chalked up in the experience column.

The land, which was purchased for other ventures, proved to be the perfect place for Balzano to follow in a long family tradition and hone his winemaking skills.

Cottonwood Winery

Surrounded by farmland, horses and llamas, Cottonwood Winery offers a large selection of New Mexico wines, including its own house labels.

Dale and Penny Taylor opened Cottonwood Winery in Artesia, New Mexico, to provide the area with a taste of New Mexico wines. Although they profess not to be wine experts, the Taylors strive to help their patrons find their own special taste preferences.

Situated to the side of Highway 62/180 north of Artesia, Cottonwood Winery is host to many local events, including vintage car shows, barbecues, wedding and baby showers and birthday parties. The pond and veranda areas that surround the winery give patrons a cool place in which to relax and get out of the desert heat.

Cottonwood Winery carries a large variety of New Mexico wine, including its own labels featuring breeds of horses. During a dispute with an Italian winery over Cottonwood's use of the name Palomino, the winery became frustrated with the red tape of the politics and renamed its delicious vanilla crème wine Jack Ass. This brings a chuckle to those who hear the story. The wine is, thankfully, none the worse for the wear and is still as delectable as ever.

Dos Viejos Winery

Nestled in the upper reaches of the Tularosa Basin, Dos Viejos Winery offers award-winning wines to those who venture off the beaten path to its door.

Owned by Robert and James Dann, Dos Viejos Winery is located on prime grape-growing soil that has produced premium products since the 1800s, and it is the hope of the vintners that "you feel a little of the land's enchantment each time you sample a glass of their 100 percent New Mexico wine."

James Dann laughingly describes himself as the "chief bottle washer, wine grower, farmer and weed puller" while his brother Robert is "the manager and computer guy."

Situated at an elevation of 4,508 feet above sea level, Dos Viejos Winery is surrounded by the Sacramento and San Andreas Mountains and the White Sands National Monument, which make for stunning views no matter where you look.

The Dos Viejos Winery, which loosely translated means "two old guys," sports a label featuring two elderly gentlemen ambling down a vineyard row. The pair is supposed to represent the owners/brothers, Robert and James.

The brothers have been in grape growing for over thirteen years, and the winery itself has been in existence for seven years. After working in the wine industry for seventeen years, the brothers decided to branch out on

their own in 2005 to start Dos Viejos, receiving their license in 2009. The killing frost of 2010 with temperatures that reached a staggering twenty-one degrees below zero took a heavy toll on Dos Viejos, eliminating 2,500 vines at the brothers' personal vineyard and another 10,000 at the commercial vineyard and placing a catastrophic hardship on the vineyard and winery.

In a stroke of luck, the brothers had just transferred eight thousand Mission grape vines to the Rio Grande Vineyard and Winery in Mesilla just before the frost struck the Tularosa Basin. These vines will be given back to Dos Viejos once they are established again. (The Mission grape is the heritage grape for New Mexico and used to grow in great abundance along the Rio Grande Valley, but today only a few vineyards grow the grape.)

Dos Viejos acquired its Mission grape cuttings from the La Luz Catholic Church, Our Lady of the Light, where the vines grew feral around the church grounds.

Dos Viejos Winery is off the beaten path but well worth the effort to find to sample the wonderful wines it offers while enjoying the company of the owners.

Heart of the Desert Winery

Specializing in pistachios, Heart of the Desert Winery is also proud to offer its signature Pistachio Rosé wine. Heart of the Desert is owned by George and Marianne Schweer, who originally purchased 175 acres of land along Highway 54/70 near Alamogordo, New Mexico. Heart of the Desert wines were added to the family's business in 2002, and from 2003 to the present, a total of twenty-four thousand grapevines have been planted due to the encouragement of the first yield.

Heart of the Desert vineyards boasts seven grape varieties, which include Chardonnay, Cabernet Sauvignon, Zinfandel, Shiraz, Riesling, Malvasia Blanca and Gewurztraminer. From these fine choices in grapes, its patrons are given a wide variety of award-winning wines to choose from as well.

The Heart of the Desert website proclaims that "the distinction of the grapes used in the wines influences their individuality, a characteristic which Heart of the Desert Vineyards is proud to exhibit."

Adhering to the rule that at least 75 percent of the grapes used in production must be grown in New Mexico to be called a true New Mexico wine, Heart of the Desert believes it is New Mexico soil, climate and patterns of cultivation that give its grapes the much desired terroir.

"The choices made in the vineyard and winery, are of relevance...as they directly affect the final product. And today, the array of choices that will affect the way the wine tastes, are unprecedented," explained George Schweer.

When visiting Heart of the Desert, you will be greeted in the parking lot by "Peppy" the pistachio, the official mascot of the Heart of the Desert pistachio farm. The Schweer family is proud of their Eagle Ranch pistachio farm and offer forty-five minute tours of the self-contained agribusiness.

Carolyn Guess has been proudly serving wine tastings at the Heart of the Desert Winery since 2010. Courtesy of the author.

Noisy Water Winery/The Relleno Brothers

In the cool pines of downtown Ruidoso, New Mexico, a quaint village in the Sacramento Mountains, are two distinctive wineries forged from the same company owned by Rick and Mary Jo Riddle.

The Relleno Brothers released their first private labeled wines in 2009 with whimsical wine labels, such as Jo Mamma's White and Jo Mamma's Red, but their bestselling label is hands down the Besito Caliente—otherwise known as Green Chile Wine. This unique wine is made from the world-famous Hatch, New Mexico green chile, which gives this semi-sweet wine an unusual kick.

As its brochure states proudly, Noisy Water Winery is "New Mexico's finest wines brought to you in the heart of the pines."

The Noisy Water Winery features a collection of Limited Reserves and Vintner Private Selects at the Cellar Uncorked tasting room. The collection highlights dry reds and sweet wines that have won an impressive array of awards in national and international competitions. Also featuring a gourmet olive oil and balsamic vinegar tasting bar, the Cellar Uncorked offers its customers a taste of twenty-five-year-old balsamic vinegars from Italy paired with olive oil.

The sister winery, The Relleno Brothers, has wines that are a sweet wine drinker's dream and handmade cheeses made from all–New Mexico products. Some of the bestsellers are the Green Chile Jack and the Green Chile Cheddar, and for the ultimate taste adventure, be sure to taste the world's hottest cheese: the Monterrey Jack Ghost Chile Cheese—guaranteed to quickly warm you up and have you reaching for a glass of your favorite wine to cool off your taste buds.

Tularosa Vineyards

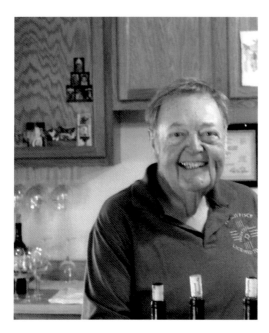

Roger Parker mans the tasting room counter at Tularosa Vineyards. *Courtesy of the author.*

As with many other vintners in the state, New Mexico is a chosen home for owner David Wickham, a native of Watkins Glen, New York. Wickham first came to the Land of Enchantment in 1968 while serving at Holloman Air Force Base; it was there he met his wife, Teresita Chavez, whose family has long ties with the Tularosa Basin area.

Wickham's initial intention was to grow a few grapevines and dabble in winemaking purely as a hobby, but after attending seminars hosted by the New Mexico Vine and Wine Society, David was hooked and purchased his first ten acres of land in 1985. Tularosa Vineyards began pouring its own labels at the winery in 1989 and hasn't looked back since.

It is David's crusade to save the historic Mission grape, a campaign that sets him apart from the rest of the fine winemakers of New Mexico. Grown literally in the backyard of his one-hundred-year-old home, the Mission grape comes full circle to the Tularosa Basin.

In full view of the awe-inspiring Sacramento Mountains, Tularosa Vineyards and Winery offers a spectacular respite among the grapevines and pistachio

Tularosa Vineyards is surrounded by pistachio trees, grapevines, twenty-five-year-old pecan trees and many yuccas, the New Mexico state flower. *Courtesy of the author.*

trees. Take a cue from Max, the winery's ever-vigilant greeter and watch dog—relax, sit back and enjoy the cool breezes as they dance on the porch. Bring a picnic lunch to enjoy with your wine selections and relish in the spectacular view.

MEADERIES

Bee's Brothers Winery

Nestled in the South Valley near Albuquerque, Bee's Brothers Winery, owned by Bill Smith, produces a delectable concoction called mead by mead maker Rick Hogan. The word mead conjures up images of Viking warriors or Knights of the Round Table with their silver-trimmed, horned goblets raised while calling for the serving wenches to replenish their drink. And yes, the drink goes back that far and beyond. Mentioned in the Rig Veda of India over six thousand years ago, mead is describes as "ambrosia" and the "nectar of the gods."

Spanish-Roman naturalist Columella gave a recipe for mead in *De re Rustica* in about AD 60:

> *Take rainwater kept for several years, and mix a sextarius (546 ml) of this water with a pound of honey. For weaker mead, mix a sextarius of water with nine ounces of honey. The whole is exposed to the sun for 40 days, and then left on a shelf near the fire. If you have no rainwater, then boil spring water.*

As with many good things, mead, or honey wine, was found by accident. Thought to be the first fermented drink, mead is diluted honey, fermented with yeast in water. Over the years, nine varieties of mead have been developed. Bee's Brothers currently makes four wines using alfalfa and wildflower honey gathered from beekeepers in the desert region of southern New Mexico. This honey gives the mead a golden color and light floral flavors, and Bee's Brothers states that the "honey we use is some of the finest honey in the world."

Falcon Meadery and Winery

One of only two commercial meaderies in New Mexico, Falcon Meadery and Winery is located in the state capital of Santa Fe.

Darragh Nagle, a native of Los Alamos, New Mexico, began making mead and winning awards in 1991. In 2005, with the help of well-known Santa Fe musician and assistant brewer Stephen Guthrie, Nagle opened Falcon Meadery and Winery. While working for the American Mead Association, Darragh promoted mead making through writing articles for the organization and supplying home brewers with the honey necessary to produce the product.

Each year, New Mexico takes on an air of Renaissance Europe during the Albuquerque Highland Games festival held in May at the Balloon Festival grounds and the Santa Fe Renaissance Faire held at El Rancho de las Golondrinas (a living cultural museum) in September. These events are two of the largest medieval-inspired gatherings in the state and bring many participants from around the country and the world. Since mead is a favored drink for festival-goers, you can find Falcon Meadery in attendance as well.

Appendix

New Mexico Vineyards and Wineries

Northern Region

Black Mesa Winery, www.blackmesawinery.com
Don Quixote Distillery and Winery, www.dqdistillery.com
Estrella Del Norte Vineyard, www.estrelladelnortevineyard.com
La Chiripada Winery, www.lachiripada.com
Santa Fe Vineyards, www.estrelladelnortevineyard.com
Vivác Winery, www.vivacwinery.com
Wines of the San Juan, www.winesoftheSanJuan.com

Boutique wineries and tasting rooms of the Northern Region:
Balagna Winery & San Ysidro Vineyards
Chimayo Ridge
Embudo Station
Jacona Valley Vineyard
Jory Winery
La Querencia
Las Nutrias Vineyard & Winery
Las Parras de Abiquiú, www.lasparras.com
Los Luceros Winery/Zia Vineyards
Madison Vineyards & Winery, www.madison-winery.com
Ritchie-Slater Winery
Sandia Shadows Vineyards
Sisneros-Torres Winery
St. Clair Winery & Bistro, Farmington, www.stclairvineyards.com

Tres Cruces Vineyard, www.estrelladelnortevineyard.com
Vino del Corazon Wine Room, www.vinodelcorazon.com

Central Region

Acequia Vineyards & Winery, www.acequiawinery.com
Anasazi Fields Winery, www.anasazifieldswinery.com
Anderson Valley Vineyards, www.avwines.com
Casa Abril Vineyards & Winery, www.casaabrilvineyards.com
Casa Rondeña Winery, www.casarondena.com
Corrales Winery, www.corraleswinery.com
Gruet Winery, www.gruetwinery.com
Guadalupe Vineyards, www.guadalupevineyards.com
Ponderosa Valley Vineyards & Winery, www.ponderosawinery.com
Tierra Encantada Winery, www.tierra-encantada.com

BOUTIQUE WINERIES AND TASTING ROOMS OF THE CENTRAL REGION:
Holley Vineyard
Hurst Vineyards
Matheson Wine Company, www.mathesonwines.com
Milagro Vineyards, www.milagrowine.com
Pasando El Tiempo, www.pasandotiempowinery.com
St. Clair Winery & Bistro, Albuquerque, www.stclairvineyards.com

Southwest Region

Amaro Winery, www.amarowinerynm.com
Blue Teal Vineyards, www.blueteal.com
Fort Selden Winery, www.fortseldenwinery.com
La Esperanza Vineyard & Winery, www.laesperanzavineyardandwinery.com
La Viña Winery, www.lavinawinery.com
Luna Rossa Winery, www.lunarossawinery.com
Rio Grande Vineyards & Winery, www.riograndewinery.com
Southwest Wines, www.southwestwines.com
St. Clair Winery, Deming, www.stclairvineyards.com

BOUTIQUE WINERIES AND TASTING ROOMS OF THE SOUTHWEST REGION:
Barbershop Winery, www.barbershopcafe.com
Bellanzi Winery, www.munzter.com/design/bellanzi
Black Range Winery & Vintage Wines, www.vintagewinesandcigars.com
Chateau Sassenage
Domaine Cheurlin/Duvallay Vineyards

Draney Orchard
Heart of the Desert, Las Cruces & Mesilla, www.heartofthedesert.com
Jaramillo Vineyards, www.jaramillovineyards.com
Josefina's Old Gate Cellars, www.josefinasoldgate.com
Luna Rossa Tasting Room, www.lunarossawinery.com
Mademoiselle Vineyards, www.mademoisellevineyards.com
San Felipe Winery, http://www.sanfelipewinery.com
Santa Rita Cellars, www.santaritacellars.com
St. Clair Winery & Bistro, Las Cruces, www.stclairvineyards.com
Sunland Winery & Wine by Design, http://prbarill.wix.com/sunlandwinery-winebydesign

Southeast Region

Arena Blanca Winery/San Tomas Vineyards, http://mcginns.mybigcommerce.com
Balzano Winery, http://www.thetrinityhotel.com
Cottonwood Winery, www.cottonwoodwineryllc.com
Dos Viejos Winery, www.dosviejoswines.com
Heart of the Desert, Alamogordo, www.heartofthedesert.com
Noisy Water Winery, www.rellenobros.com
Tularosa Vineyards, www.tularosavineyards.com

BOUTIQUE WINERIES AND TASTING ROOM OF THE SOUTHEAST REGION:
The Cellar Uncorked, www.rellenobros.com
Pecos Flavors Winery, http://pecosflavorswinery.com
Willmon Vineyards, www.endofthevine.com

Meaderies

Bee's Brothers Winery, Albuquerque, www.beesbrothers.com
Falcon Meadery, Santa Fe, www.falconmead.com

WINE ASSOCIATIONS

New Mexico Vine and Wine Society, www.vineandwine.org
New Mexico Wine Country, www.winecountrynm.com
New Mexico Wine Growers Association, www.NMWine.com
Northern New Mexico Micro Grape Growers Association
Viticulture Enology Science and Technology Alliance (VESTA)

NEW MEXICO WINE FESTIVALS

Albuquerque Wine Festival—Memorial Weekend
Carlsbad Winter Wine Festival—December
Fall Harvest Festival—La Viña Winery—October
Harvest Wine Festival—Labor Day Weekend, Southern New Mexico
La Viña Spring Wine Festival—Memorial Weekend
New Mexico Wine Festival—Labor Day Weekend, Bernalillo
Red River Fine Art & Wine Festival—June
Santa Fe Wine and Chile Fiesta—September
Santa Fe Wine Festival at El Rancho de las Golondrinas
Southern New Mexico Wine Festival—Memorial Weekend
Toast of Taos Wine Festival and Golf Tournament—June
Tularosa Basin Wine and Music Festival—September

Santa Fe Wine Festival held at the El Rancho de Las Golondrinas, a living culture museum, in July. *Courtesy of the author.*

Bibliography

Allen, John Houghton. *Southwest*. Albuquerque: University of New Mexico Press, 1977.

Anderson, George B. *History of New Mexico: Its Resources and People*. Vol. 2. Los Angeles: Pacific States Publishing Company, 1907.

Applegate, Frank G. *Indian Stories from the Pueblos*. Albuquerque, NM: Rio Grande Press, 1977.

Ashcroft, Bruce. *The Territorial History of Socorro, New Mexico*. El Paso: University of Texas, 1988.

Behr, Edward. *Prohibition: Thirteen Years that Changed America*. Boston: Little, Brown & Company, 1996.

Bogener, Steve. *Ditches Across the Desert: Irrigation in the Lower Pecos Valley*. Lubbock: Texas Tech University Press, 2003.

Boyle, Susan Calafate. *Los Capitalistas: Hispano Merchants on the Santa Fe Trade*. Albuquerque: University of New Mexico Press, 1997.

Brooks, Becky, Carman Estrada, Elvi Nieto and Ruth Vise. "A Taste of Southwest Wine." *Borderlands* 25, no. 16 (2006–7).

Cabeza de Baca, Fabriola. *We Fed Them Cactus*. Albuquerque: University of New Mexico Press, 1994.

Cabeza de Vaca, Álvar Nuñez. *Adventures in the Unknown Interior of America*. Albuquerque: University of New Mexico Press, 1983.

Campa, Arthur L. *Hispanic Culture in the Southwest*. Norman: University of Oklahoma Press, 1979.

Castaño de Sosa, Gasper. *A Colony on the Move: Gaspar Castaño de Sosa's Journal, 1590–1591*. Edited by Albert H. Schroeder. Translated by Daniel Shaw Matson. Santa Fe, NM: School of American Research, 1965.

Chavez, Fray Angelico. *Origins of New Mexico Families: A Genealogy of the Spanish Colonial Period*. Revised edition with foreword by Thomas E. Chavez. Santa Fe: Museum of New Mexico Press, 1992.

Chavez, Thomas E. *An Illustrated History of New Mexico.* Albuquerque: University of New Mexico Press, 2002.

Cortés y de Olarte, José. *Views from the Apache Frontier: Report on the Northern Provinces of New Spain.* Edited by Elizabeth A.H. John. Translated by John Wheat. Norman: University of Oklahoma Press, 1994.

Crane, Leo. *Desert Drums: The Pueblo Indians of New Mexico, 1540–1928.* Glorieta, NM: Rio Grande Press, Inc., 1972.

Daniel-Davila, Ungelbah. "New Mexico Wineries First Broke Ban by Spanish Government, Then Boomed in the 1870s." *Mountain View Telegraph,* November 17, 2011.

Davis, Mary P., and the Corrales Historical Society. *Corrales.* Charleston, SC: Arcadia Publishing Company, 2012.

Davis, William Watts Hart. *El Gringo, or New Mexico and Her People.* Lincoln: University of Nebraska, 1982.

Defouri, Reverend James H. *Historical Sketch of the Catholic Church in New Mexico.* San Francisco, CA: McCormick Brothers Printers,1887.

Dominguez, Fray Francisco Atanasio. *The Missions of New Mexico, 1776.* Translated and annotated by Eleanor B. Adams and Fray Angelico Chavez. Albuquerque: University of New Mexico Press, 1956.

Espinosa, Gilberto, Tiro J. Chavez and Carter M. Waid. *El Rio Abajo.* Pampa, TX: Pampa Print Shop, 1973.

Espinosa, Jose Manuel. *Crusaders of the Rio Grande: The Story of Don Diego de Vargas and the Reconquest and Refounding of New Mexico.* St. Louis, MO: Institute of Jesuit History, 1942.

Etulain, Richard W. *New Mexico Lives: Profiles and Historical Stories.* Albuquerque: University of New Mexico Press, 2002.

Flint, Richard, ed. *Coronado Expedition to Tierra Nueva: The 1540–1542 Route across the Southwest.* Niwot: University Press of Colorado, 1997.

Garcia, Nasario. *Más Antes: Hispanic Folklore of the Rio Puerco Valley.* Santa Fe: Museum of New Mexico Press, 1997.

Gregg, Josiah. *Commerce of the Prairies.* Norman: University of Oklahoma Press, 1954.

Hall-Quest, Olga (Wilborne). *Conquistadors and Pueblos: The Story of the American Southwest, 1540–1848.* New York: Dutton, 1969.

Hammond, George P., and Agapito Rey, eds. *New Mexico in 1602: Juan de Montoya's Relation of the Discovery of New Mexico.* Albuquerque: Quivera Society, University of New Mexico Press, 1938.

Harbert, Nancy. *New Mexico.* Compass American Guides. Oakland, CA: Fodor's, 1992.

Hatch Valley Friends of the Library. *History of the Hatch Valley.* Hatch, NM, 1989.

Hendricks, Rick. "Wine Production in El Paso and the Grapevine Inventory of 1755." Office of the New Mexico State Historian. http://www.newmexicohistory.org/filedetails.php?fileID=525.

Hewett, Edgar L., and Reginald G. Fisher. *Mission Monuments of New Mexico.* Albuquerque: University of New Mexico Press, 1943.

Hollon, W. Eugene. *The Southwest: Old and New.* New York: Alfred A. Knopf, 1961.

Holtby, David V. *Forty-Seventh Star: New Mexico's Struggle for Statehood.* Norman: University of Oklahoma Press, 2012.

BIBLIOGRAPHY

Horgan, Paul. *The Great River: The Rio Grande in North American History.* Hanover, NH: Wesleyan University Press, 1954.

Jenkins, Myra Ellen, and Albert H. Schroeder. *A Brief History of New Mexico.* Albuquerque: University of New Mexico Press, 1974.

Johnson, Linda. *The Wine Collector's Handbook: Storing and Enjoying Wine at Home.* New York: Lyons Press, 1997.

Jones, Oakah L. *Los Paisanos: Spanish Settlers on the Northern Frontier of New Spain.* Norman: University of Oklahoma Press, 1979.

Kenner, Charles L. *Comanchero Frontier: A History of New Mexican–Plains Indian Relations.* Norman: University of Oklahoma Press, 1994.

Kessell, John L. *Kiva, Cross and Crown: The Pecos Indians and New Mexico, 1540–1840.* Albuquerque: University of New Mexico Press, 1987.

———. *Spain in the Southwest: A Narrative History of Colonial New Mexico, Arizona, Texas and California.* Norman: University of Oklahoma Press, 2002.

Kraemer, Paul. "Origins of New Mexico's Wine Industry." *Tradición* (September 2011).

LaFarge, Oliver. *Santa Fe: The Autobiography of a Southwestern Town.* Norman: University of Oklahoma Press, 1980.

Lummis, Charles Fletcher. *Land of Poco Tiempo.* Albuquerque: University of New Mexico Press, 1952.

Magoffin, Susan Shelby. *Down the Santa Fe Trail and into Mexico: The Diary of Susan Shelby Magoffin, 1846–47.* Edited by Stella M. Drumm. Lincoln: University of Nebraska Press, 1982.

Melzer, Richard, Robert Torrez and Sandra K. Mathews. *A History of New Mexico Since Statehood.* Albuquerque: University of New Mexico Press, 2011.

Metzger, Stephen. *New Mexico Handbook.* Chico, CA: Moon Publications, Inc., 1994.

Miller, Joseph. *New Mexico: A Guide to the Colorful State.* New York: Hastings House, 1953.

Moorhead, Max L. *New Mexico's Royal Road: Trade and Travel on the Chihuahua Trail.* Norman: University of Oklahoma Press, 1995.

Nichols, Shan. "Making Wine Along the Rio Grande: An Overview." *Southern New Mexico Historical Review* 10, no. 1 (January 2003): 1–5.

Niemeyer, Lucian, and Art Gómez. *New Mexico: Images of a Land and Its People.* Albuquerque: University of New Mexico Press, 2004.

Okrent, Daniel. *Last Call: the Rise and Fall of Prohibition, 1920–1933.* New York: Scribner, 2010.

Peixotto, Ernest. *Our Hispanic Southwest.* New York: Charles Scribner's Sons, 1916.

Pérez de Villagrá, Gasper. *History of New Mexico, Alcalá, 1610.* Albuquerque, NM: Quivera Society, Arno Press, 1967.

Phillips, Fred M., G. Emlen Hall and Mary Black. *Reining in the Rio Grande: People, Land, and Water.* Albuquerque: University of New Mexico Press, 2011.

Prince, L. Bradford. *Concise History of New Mexico.* Cedar Rapids, IA: Torch Press, 1912.

Robinson, Jancis. *Jancis Robinson's Guide to Wine Grapes.* New York: Oxford University Press, 1996.

Sandersier, Andy. *The Wines of New Mexico.* Albuquerque: University of New Mexico Press, 2005.

Sandoval County Historical Society. *Fruit of the Vine: A History of Wine Making in Sandoval County.* Bernalillo, NM, 1993.

Silverman, Jason. *Untold New Mexico: Stories from a Hidden Past.* Santa Fe, NM: Sunstone Press, 2006.

Simmons, Marc. *Coronado's Land: Essays on Daily Life in Colonial New Mexico.* Albuquerque: University of New Mexico Press, 1991.

———. *The Old Trail to Santa Fe: Collected Essays.* Albuquerque: University of New Mexico Press, 1996

———. *Spanish Pathways: Readings in the History of Hispanic New Mexico.* Albuquerque: University of New Mexico Press, 2001.

———. *Taos to Tomé: True Tales of Hispanic New Mexico.* Santa Fe: Ancient City Press, 1978.

Sinclair, Andrew. *Prohibition, Era of Excess.* Norwalk, CT: Easton Press, 1986.

Sinclair, John L. *New Mexico: The Shining Land.* Albuquerque: University of New Mexico Press, 1980.

Sonnichsen, C.L. *Pass of the North: Four Centuries on the Rio Grande.* El Paso: Texas Western Press, 1968.

Street, Henry K. *The History of Wine in New Mexico: 400 Years of Struggle.* Ponderosa, NM: Ponderosa Valley Vineyards and Winery, 1997, 2012.

Treib, Marc. *Sanctuaries of Spanish New Mexico.* Berkeley: University of California Press, 1993.

Twitchell, Ralph. *Leading Facts of New Mexico History.* Vol. 1. Santa Fe, NM: Sunstone Press, 2007.

Vargas, Diego de. *Remote Beyond Compare: Letters of Don Diego de Vargas to His Family from New Spain and New Mexico, 1675–1706.* Albuquerque: University of New Mexico Press, 1995.

———. *To the Royal Crown Restored: The Journals of Don Diego de Vargas, New Mexico, 1692–1694.* Edited by John L. Kessell, Rick Hendricks and Meredith D. Dodge. Albuquerque: University of New Mexico Press, 1995.

Vélez de Escalante, Silvestre. *Diary and Travels of Fray Francisco Atanasio Dominguez and Fray Silvestre Vélez de Escalante: To Discover a Route from the Presidio of Santa Fe, New Mexico to Monterey in Southern California.* Salt Lake City: Catholic Church in Utah, ca. 1909.

Warner, Ted J., ed. *The Dominguez-Escalante Journal: Their Expedition through Colorado, Utah, Arizona and New Mexico in 1776.* Translated by Fray Angelico Chavez. Salt Lake City: University of Utah Press, 1995.

Weber, David J. *The Mexican Frontier, 1821–1846: The American Southwest under Mexico.* Albuquerque: University of New Mexico Press, 1982.

Weber, David J., ed. *New Spain's Far Northern Frontier: Essays of Spain in the American West, 1540–1821.* Albuquerque: University of New Mexico Press, 1979.

———. *The Spanish Frontier in North America.* New Haven: Yale University Press, 1992.

Index

About the Author

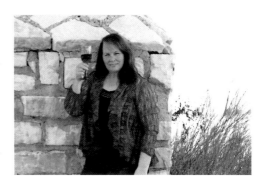

Donna Blake Birchell, author of two books on local New Mexico history, *Carlsbad and Carlsbad Caverns* and *Eddy County*, developed a passion for history through the inspiration of her history buff parents, William and Dorothy Blake. While doing research for her other books, the native New Mexican discovered a lack of written history of New Mexico's fascinating wine industry. This discovery, coupled with her ever-evolving love of wine, led Birchell to correct the oversight. Although New Mexico is diverse in many ways, she found that one thing remains constant: the friendliness of the people. She was consistently greeted with eager smiles, hardy handshakes and enough stories to fill three volumes.

Visit us at
www.historypress.net

This title is also available as an e-book